IMAGES
of America

WYOMING

D1451853

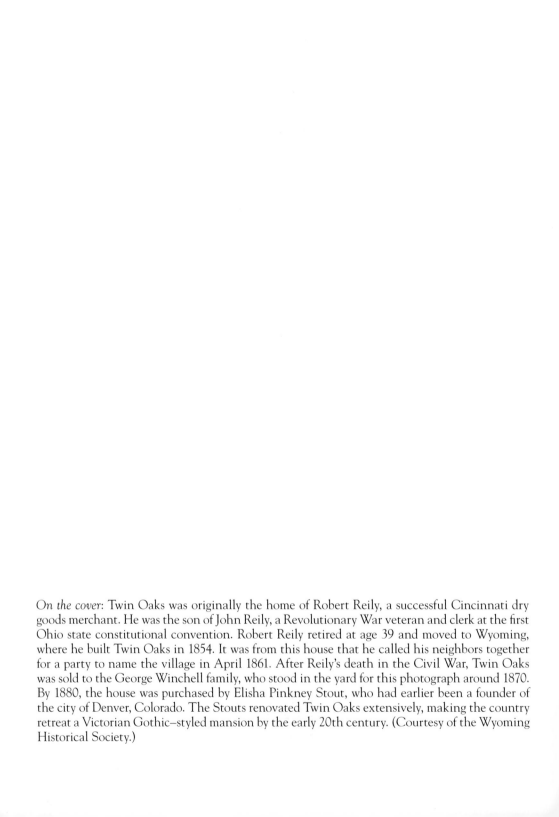

On the cover: Twin Oaks was originally the home of Robert Reily, a successful Cincinnati dry goods merchant. He was the son of John Reily, a Revolutionary War veteran and clerk at the first Ohio state constitutional convention. Robert Reily retired at age 39 and moved to Wyoming, where he built Twin Oaks in 1854. It was from this house that he called his neighbors together for a party to name the village in April 1861. After Reily's death in the Civil War, Twin Oaks was sold to the George Winchell family, who stood in the yard for this photograph around 1870. By 1880, the house was purchased by Elisha Pinkney Stout, who had earlier been a founder of the city of Denver, Colorado. The Stouts renovated Twin Oaks extensively, making the country retreat a Victorian Gothic–styled mansion by the early 20th century. (Courtesy of the Wyoming Historical Society.)

IMAGES
of America

WYOMING

Rebecca Strand Johnson

Published by Arcadia Publishing
Charleston SC, Chicago IL, Portsmouth NH, San Francisco CA

Printed in Great Britain

Library of Congress Catalog Card Number: 2005933417

For all general information contact Arcadia Publishing at:
Telephone 843-853-2070
Fax 843-853-0044
E-mail sales@arcadiapublishing.com
For customer service and orders:
Toll-Free 1-888-313-2665

Visit us on the internet at http://www.arcadiapublishing.com

CONTENTS

ACKNOWLEDGMENTS

A photographic history is a collaborative project, even if just one author appears on the byline. That author is grateful to the many local historians who have made this book possible, either by sharing their personal photographic collections and memories or by pointing to someone else who had information about Wyoming's history.

The Wyoming Historical Society enthusiastically opened its archives to this project, providing photographs, files, and technical assistance. Sherry Sheffield, Ed Hand, Mary Lou Mueller, Jo Sanders, and Glen Lewis were instrumental in their support and encouragement of this work.

Many people and places have opened their doors and photo albums for the sake of this history about Wyoming. Many thanks go to Gene-Ann Good Cordes, Roger and Mary Honebrink, Virginia Glick, Patsy Gaines, the Wyoming Presbyterian Church, St. James of the Valley Roman Catholic Church, and the late Adelia Brownell.

Nancy and Frank Foster shared Alice Foster's exceptional photography without hesitation. Wyoming is fortunate to have had this woman document its past so beautifully. And Dan Finfrock shared not only his archival photographs but an extensive knowledge about the railroad in Cincinnati. He is the best kind of educator.

In particular, I am grateful to John Diehl, for trusting that his wonderful collection of archival material and photographs would be safe in my hands, and to his wife, Jane, for convincing him of that.

Jan Evans and Annie Lou Helmsderfer, unofficial partners in this project, provided fact-checking and professional editing. They are truly Wyoming's historians.

Finally, a special thanks goes to my family. My husband and parents picked up all my slack, and my children kept me firmly in the present, even as my mind drifted into the past.

INTRODUCTION

The city of Wyoming today is a place of quiet, tree-lined streets, elegant Victorian architecture, and excellent schools. Its small-town flavor belies an easy commute to large city attractions and businesses. Wyoming was founded because of this convenience, and few residents today can imagine the great wilderness and its dangers that stood between this area and the tiny settlements on the Ohio River only 200 years ago.

Wyoming before 1800 was a patchwork of heavily forested hills and creeks that fed a meandering stream, now known as the Mill Creek, running south to the Ohio River. The Adenas, indigenous people who lived in this area from 1000 BC to AD 700, left behind ceremonial enclosures and burial mounds, including a large one once located at the northernmost section of present-day Wyoming. Populations of Hopewell Indians later lived in the area but disappeared long before French trappers and English traders met the seven Native Americans tribes that lived and traveled throughout the Ohio territory: the dominant Miami and Shawnee and other more northern and eastern settlements of Ottawa, Pottawatomie, Wyandot, Mingo, Tuscarawas, and Muskingum.

The Northwest Ordinance was passed in 1787, giving the fledging United States a plan for the governance of new territories and the organization of new states. Interest in the Ohio Valley began long before this, however, as colonial men returned from their service in the French and Indian War and told of the fertile land lying north of the Ohio River. Benjamin Stites, a soldier who had traded on the Ohio, convinced Judge John Symmes, a congressman from New Jersey, to negotiate for a large tract of land in this new territory to sell to pioneers. The Miami (or Symmes) Purchase was the result, and soon thereafter, the Ohio Valley began seeing permanent white settlement.

The Ohio Company, which controlled eastern land on the Ohio River, based development on a historic New England approach: concentrating settlers in villages and on the river to protect them from Native American attacks. Symmes's plan allowed every purchaser to choose his own ground and convert it into a "station." Settlers were less protected, but the interior of the vast land was settled with faster, broader strokes. Although there were numerous Native American attacks in those early years, these stations popped up throughout the Miami Purchase, aided by the government installations at Fort Washington on the Ohio River and Fort Hamilton, 25 miles north on the Great Miami River. White's station, built around 1792 on the Mill Creek near present-day Carthage, saw several area attacks by natives. Nearby Tucker's station, a blockhouse and cabins surrounded by a stout picket made of tree trunks and logs, and Pleasant Valley Station, just north of present-day Wyoming, were spared from Native American attacks because of Gen. Anthony Wayne. His success in 1794 at the Battle of Fallen Timbers near Toledo and the peace treaties that followed opened up this region for safe and permanent settlement.

Settlers began arriving in earnest after the Indian wars. Losantiville, renamed Cincinnati by the territory's governor, Gen. Arthur St. Clair, grew at a quick pace because of increasing river traffic and trade. Young men and adventurous families braved the long journey down the Ohio River on keelboats, docked in the dirty, new town, and then looked for ways north into

the wilderness. Alexander Pendery purchased land from John Symmes and built his hewn log cabin on the picturesque edge of the Mill Creek Valley. He was joined soon after by Thomas Wilmuth, a veteran of the Continental Army, who settled in Cincinnati but, by 1798, had grown tired of the bustling frontier town. Thomas Wilmuth's first wife was Mary, Alexander Pendery's sister, and Pendery offered Wilmuth 40 acres of his land to homestead. Together they began to clear their part of the valley for planting. William Evatt moved up the Mill Creek to present-day Lockland in 1805 with his family. After his death in 1813, his wife and daughter moved away from the creek, and neighboring settlers helped them build a cabin and clear three acres near Pendery and Wilmuth. Together they were the earliest pioneers in what is present-day Wyoming.

The pace of settlement was slow, and the outlying wilderness, including Wyoming, remained sparsely settled. Most roads into the territory were nothing more than deer trails and Native American paths, and anything wider was impassible in wet weather. Those who did establish farms found it difficult, without transportation, to market their crops. But a new road was being planned, and it would be the main route into Wyoming then—and today.

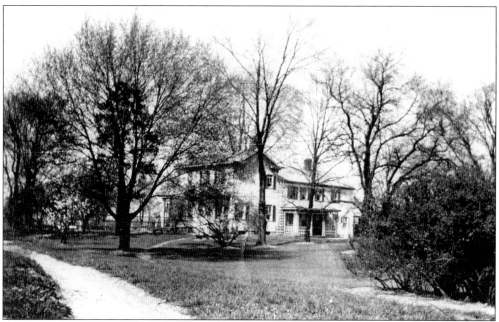

Alexander Pendery came down the Ohio River on a keelboat to Cincinnati in 1806. At Ludlow Station, he met and married Mary Ludlow, and together they traveled north up the Old Wayne Road to Pendery's 140 acres of land in the Mill Creek valley. There, he built a log home, improving it with framed additions over the years. The land stayed in the Pendery family until the house and remaining three acres were sold to the City of Wyoming in the 1960s for $35,000. The house was torn down to make room for the new Wyoming Middle School, which was soon reconstructed as the present high school. (Courtesy of the Wyoming Historical Society.)

One

A ROAD INTO THE WILDERNESS

By 1794, an old Native American trail along the Mill Creek had been tramped into a narrow road, named the Old Wayne Road after Gen. Anthony Wayne. This "Great Road," as it was also called, was the only land route into the Mill Creek Valley, connecting Fort Washington on the Ohio River with Fort Hamilton, 25 miles north. Muddy, rutted, and barely passable by wagon, it brought the first settlers into this valley.

In 1806, a new road was carved through the woodlands that greatly influenced the future of Wyoming. This road acted as a shortcut for those traveling along the Great Road. It left the Old Wayne Road at what is now the intersection of Paddock, Vine, and Anthony Wayne Avenues in Carthage and ran due north along a Symmes Purchase section line, rejoining the Great Road in the southern part of Glendale, near where Routes 4 and 747 intersect today. In 1817, it was improved as a "corduroy road" with rows of logs laid side by side and packed over with dirt. These improvements brought settlers from Pennsylvania, New Jersey, Maryland, and New York into the Wyoming Valley. Into this community came the Burns, Mayhews, Olivers, and Allens.

In 1834, Ohio passed legislation authorizing the building of a toll road between Hamilton, Springfield, and Carthage. This area's old "shortcut" road was reconstructed to state specifications then. Tolls of about 6¢ were charged every 10 miles for a horse and rider, but livestock on foot accounted for much of the traffic as the animals were herded to the slaughterhouses in Cincinnati. Local farmers Archibald Burns, Alexander Pendery, and Isaac Riddle put their own money into improving the road and recouped their investments with the tolls. Stone markers were placed at each mile of the turnpike. Tollhouses were also established regularly along the route; the one in Wyoming was on the west side of the turnpike, opposite Chestnut Street.

Sometime after 1834, the date the toll road was named, the town of Springfield shrunk and lost its village status in Ohio. When it was large enough to become a village again, another Ohio town east of Dayton had taken its name. The southern town was forced to find another name, eventually choosing "Springdale." As years passed, the Hamilton, Springfield, and Carthage Turnpike shortened the last word to "Pike" in conversation and dropped the names Hamilton and Carthage for the same reason. It is now officially known as Springfield Pike.

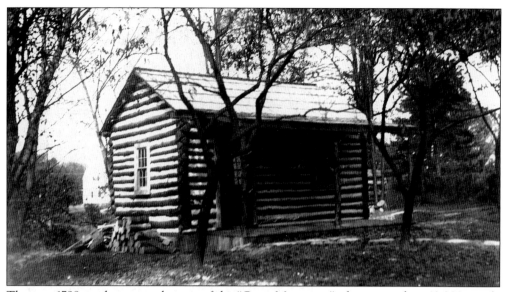

The year 1788 was known as the year of the "Great Migration," when more than 10,000 people crossed the Cumberland Gap into Virginia's Kentucky County. Few came north of the Ohio River, however. The place was referred to as the "Miami Slaughterhouse" because of numerous Native American attacks there. Log homes like this reproduction in Wyoming, built as a playhouse, dotted the landscape of the Miami Purchase once the Treaty of Greensville, signed in 1795, cleared Native Americans from their ancestral lands in Ohio. (Courtesy of the Wyoming Historical Society.)

This advertisement for a tavern appeared in the *Liberty Hall and Cincinnati Mercury* on September 10, 1808. An enterprising James Patterson planned to supplement his farming income near the new shortcut road running along what is now Springfield Pike. (Courtesy of John Diehl.)

Mary Ludlow Pendery was the first white baby girl born in the new Miami Purchase. Her father, Capt. John Ludlow, gave 15-year-old Mary and her new husband Alexander a military escort up the Old Wayne Road into the wilderness of the Mill Creek Valley. (Courtesy of the Wyoming Historical Society.)

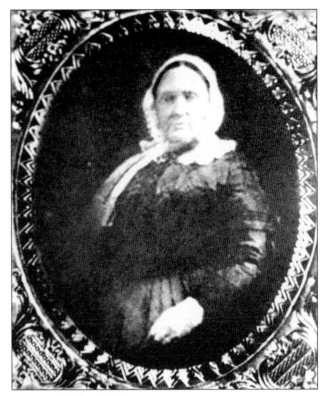

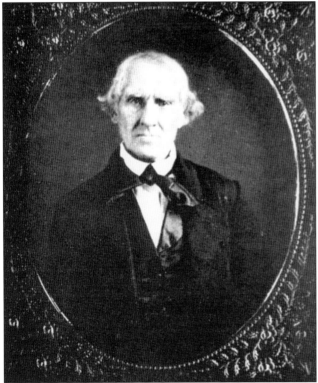

Alexander Pendery was raised in Falling Waters, Virginia, and, after his mother's death, he adventured west to Ohio. He purchased land near the banks of the Mill Creek, selecting the site because of a natural spring there. In the farm's fields, young boys regularly found arrowheads, hammers, and other Native American implements, unearthing what was probably a meeting ground for generations of Native Americans. (Courtesy of John Diehl.)

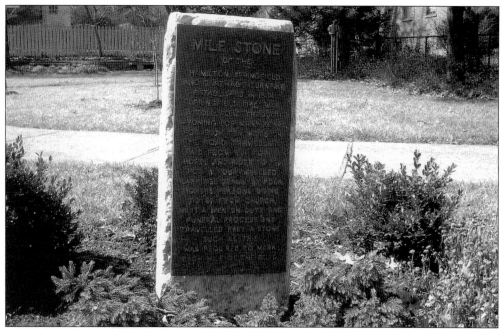

Stone pillars marked every mile on the Springfield, Hamilton, and Carthage Turnpike. This marker is the last remaining one in Wyoming, located in Centennial Park at the corner of Linden Drive and Springfield Pike. A Wyoming toll taker was asked once how he kept track of receipts. The keeper said that he kept a stone jug in the corner, and as coins were received, he tossed them toward the jug. The money that landed in the jug went to the turnpike company, and the rest he kept for himself. (Author photograph.)

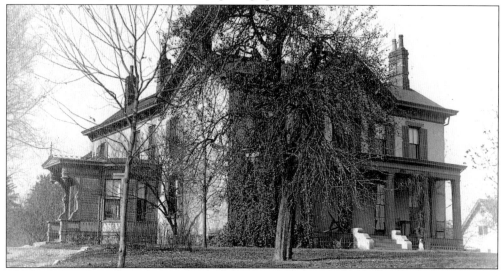

The log cabin that the widow Evatt and her daughter Jane moved to in 1813 was abandoned when Isaac Riddle built his new house in 1832. George Friend, a hardworking young man from Cincinnati, helped fire the bricks for Riddle. Twenty-five years later, after making his fortune in a Lockland paper mill, Friend purchased the same house he had helped to build, now known as the Friend-Riddle House, and lived there until his death. (Courtesy of the Wyoming Historical Society.)

Israel Harrison Pendery, born in 1830 on his father's farm, died in the same room 76 years later. As a boy, he plowed fields that are now streets and fine homes. With his wife, Mary Van Zandt, he had five children. Pendery served the community as a school trustee, the director of the county infirmary, and a township trustee. (Courtesy of the Wyoming Historical Society.)

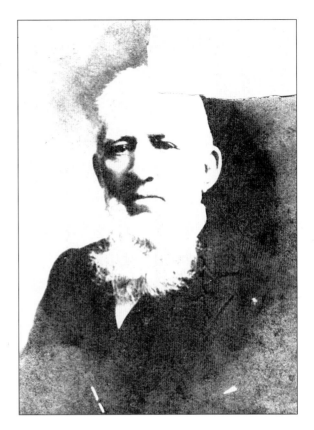

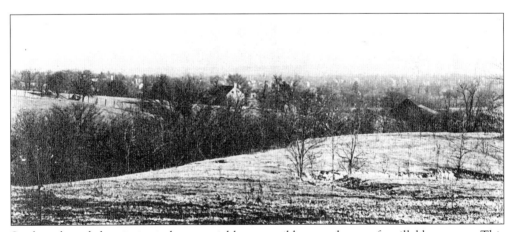

Settlers cleared the virgin timber as quickly as possible to make way for tillable acreage. This 1900 view of the hills over the Wyoming valley shows few trees across the rolling terrain. Only in the late 1800s did residents begin to reforest their community with young trees, encouraged by the Wyoming Improvement Society. (Courtesy of the Wyoming Historical Society.)

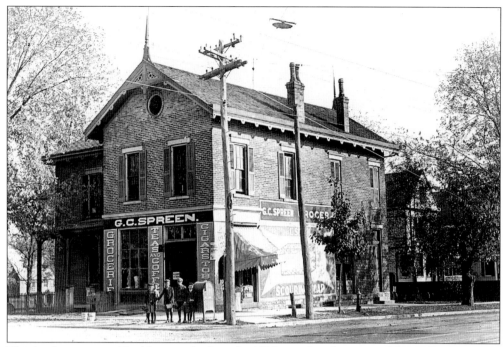

This brick commercial building was built in the 1880s to take advantage of the traffic moving up and down the Hamilton, Springfield, and Carthage Turnpike. Although it was originally owned and operated by a man named Jacoby, it was owned for many years by August Spreen. As a young man, Spreen delivered goods by wagon for the Jacobys, before purchasing the grocery himself in 1890. During the Depression, it was sold to Joseph Peebles and then later to Joseph Sansone. (Courtesy of the Wyoming Historical Society.)

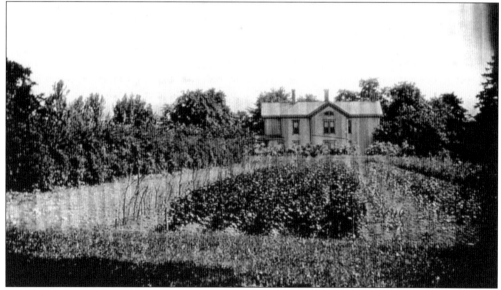

Amelia Stearns saw this view of 229 West Hill from her house on what is now Linden Lane. Fields and woods separated most homes on the western Wyoming hillside before 1900, and 100-acre farms were common there. (Courtesy of John Diehl.)

Two

THE MIAMI
AND ERIE CANAL

The most profound effect on Ohio's early development was from the extensive, 1000-mile canal system the state created during the first half of the 19th century. Then the longest canal system in the world, the Miami and Erie Canal gave the Mill Creek Valley its first manufacturing center. The canal also influenced the route of the railroad, which followed the course of the waterway and directed Wyoming's development as a convenient and pleasant bedroom community for Cincinnati.

The Erie Canal, completed in 1825, ran from Buffalo to Albany, New York, and was a great success in transporting goods easily and cheaply from the Great Lakes to the East Coast. Following New York's lead, legislators from the young state of Ohio proposed two canals for this state: the Ohio and Erie, which ran between Cleveland and the Ohio River, and the Miami and Erie, running between Cincinnati and Toledo on Lake Erie. Work started on the canals in 1825, and both canals took about 10 years to build.

The Miami and Erie Canal traveled from Cincinnati north into the wide valley created by the Mill Creek, passing through Cumminsville, Carthage, Crescentville, and Rialto, then heading north through Middletown, Dayton, Sidney, and Defiance before ending in Toledo. In the section of the canal due east of Wyoming, four locks lowered the waterway 48 feet, creating an abundance of hydropower from the fall. From that energy source, and the convenient supply and transportation route created by the canal, a manufacturing center emerged there, known as "Lockland." Industries lining the waterway manufactured paper, starch, flour, cotton, and lumber, all produced from the raw goods that floated up and down the canal. Lockland's industrial growth led directly to the residential growth of Wyoming, as company owners looked for property away from the bustle, noise, and stench of Lockland's factories. George Stearns, George Friend, and George House, all wealthy Lockland industrialists, chose the Wyoming area to commute from by horseback and carriage. To make travel easier between settlements, a dirt path was cut through the trees from Lockland. Known then as Lockland Lane, it is now called Wyoming Avenue.

The Miami and Erie Canal posted its highest earnings—$353,000—in 1851, the same year that the first train chugged through Wyoming. Trains were faster, and tracks were cheaper to build, could lie anywhere, and could be used in the winter. While goods still traveled along canal routes well into the 20th century, the Miami and Erie Canal became a place of recreation in its last years.

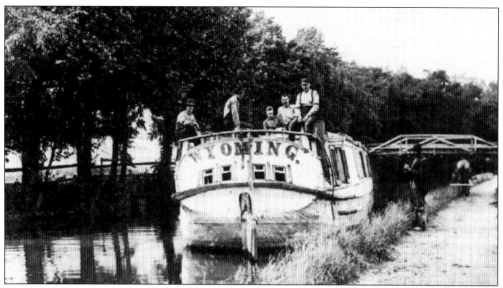

The water used for the Miami and Erie Canal was maintained by man-made lakes like Grand Lake-St. Mary's, Laramie Lake, and Indian Lake, which impounded water for canal use. Stretches of the canal were frequently closed because of flooding in the spring, a local cloudburst, low water from a dry spell, or the ice that froze over the waterway in winter months. (Courtesy of John Diehl.)

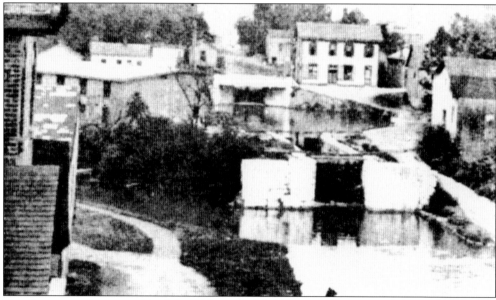

Canal construction started in July 1825 at the Mad River in Dayton and descended the Big Miami Valley and into the Mill Creek Valley. By 1827, the first canal boats traveled between Cincinnati and Middletown, passing through these locks. Lockland, due east of Wyoming, was platted in 1829 by Louis Howell and Nicholas Longworth, and the thriving industrial center that developed there included the paper mills of Friend, Fox, Haldeman, and Tangeman, the George Fox Starch Factory, the flour mills of Palmer Brothers and House, and the Stearns and Foster Cotton and Lockland Lumber Companies, owned by George Stearns. Most of these industrialists built homes in Wyoming. (Courtesy of John Diehl.)

One of the most influential men to live in Wyoming was George Stearns. He and his heirs developed an international business in Cincinnati and, in Wyoming, a legacy of elegant vernacular architecture in the homes they built. George Stearns, it is told, took an early morning walk from his Lockland factory into what is now Wyoming and, turning to see the sun rise over the cornfields and the Reading hills in the distance, he decided to build his future home there. Stearns branched into real estate development and lumber sales as his fortunes grew, and his involvement heavily influenced the use of wood over brick in the developing Victorian architecture of Wyoming. (Courtesy of the Wyoming Historical Society.)

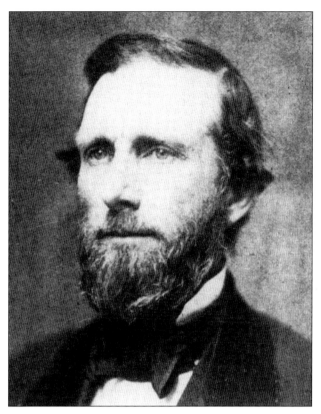

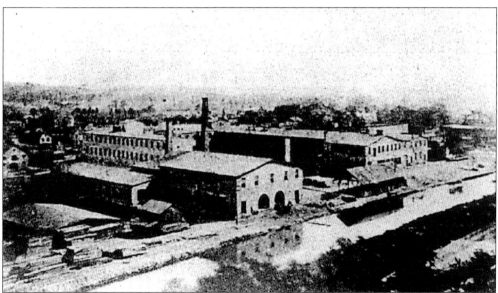

George Stearns was newly married when he and his friend Seth Foster developed a durable material called cotton wadding. It did not tear when stretched, making the material perfect for mattresses. The first Stearns and Foster manufacturing plant was in Cincinnati, but Stearns moved his factory to Lockland, where this photograph was taken. (Courtesy of the Wyoming Historical Society.)

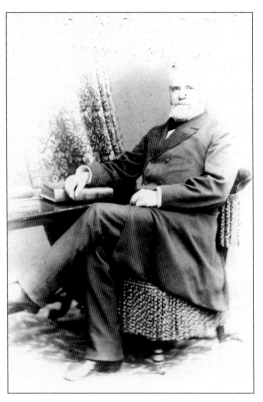

Thomas Fox, born in 1822, moved his father's starch factory to Lockland in 1856 and renamed it Larkin, Fox and Brothers. He then joined with partner Col. George Friend to create the Friend and Fox Paper Company in Lockland in 1868. Fox was also one of the founding members of the Wayne Avenue Methodist Church in Lockland, built in 1874. Its congregation eventually moved to Wyoming and became Friendship Methodist. (Courtesy of the Wyoming Historical Society.)

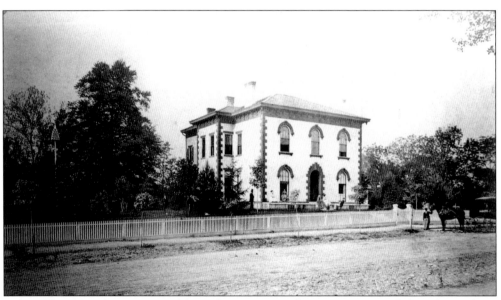

Industrialists like Thomas Fox and his wife, Margaret Belle Benson Fox, settled on the outskirts of Lockland. His Lockland home on Wyoming Avenue, built in 1860, was considered a showplace in its day. During this time, the railroad tracks had not so precisely separated the Lockland and Wyoming communities. (Courtesy of the Wyoming Historical Society.)

George House, a flour manufacturer in Lockland, purchased a corner of the Wilmuth farm and built this country estate in 1868. He was enchanted by the Italianate style, which had originated in England as a reaction to formal classical designs. (Courtesy of the Wyoming Historical Society.)

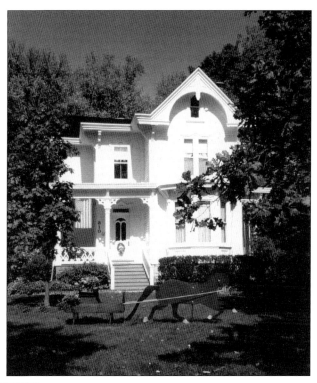

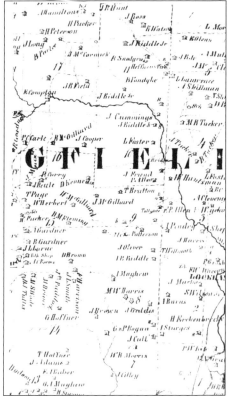

This plat map of Springfield Township, done in 1847, still shows a rural community, with acres of fields and woods separating the homes there. Canal transportation had made these farms successful. A bushel of wheat sold to the glutted local market for 20¢, but shipped by the canal, it sold for 75¢. Goods also came into the Mill Creek at a much cheaper price than before. (Courtesy of the Public Library of Cincinnati and Hamilton County.)

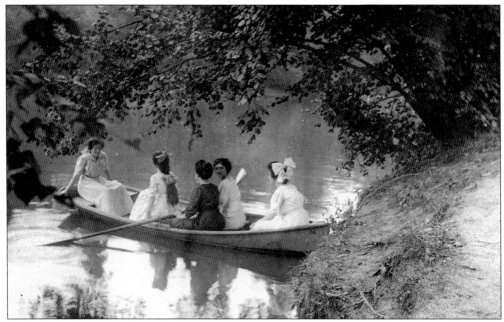

Many people enjoyed the canal recreationally in its final years. Youngsters chose to swim in the water above Lockland, where it was fresh and clear, not tainted by the unregulated pollution flowing from Lockland factories. (Alice Firbank Foster photograph; courtesy of Frank and Nancy Foster.)

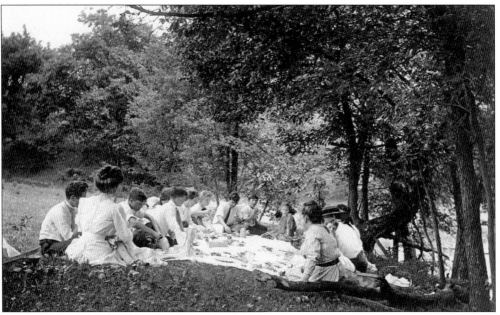

Wyoming residents, like these, used the banks of the canal for many outings and picnics. Men would fish and go duck hunting near the still waters of the channel. Years after the canal was closed, Cincinnati made use of the public lands there by constructing Central Parkway along its route and, in the 1940s and 1950s, running Interstate 75 along its Lockland section. (Alice Firbank Foster photograph; courtesy of Frank and Nancy Foster.)

Three

THE ARRIVAL
OF THE RAILROAD

On September 23, 1851, the arrival of the Cincinnati, Hamilton, and Dayton Railway line foretold the end of canal transportation and the true beginning of Wyoming's development as a suburb of Cincinnati. Before the railway, it took an entire day on horse, on foot, or by canal to reach Cincinnati. Roads were better than those early, muddy trails that wound through the forests of the Ohio Valley, but travel was still slow and uncomfortable. The Miami and Erie Canal packet boats offered passengers a smooth ride but traveled, on average, about four miles an hour.

What is hard to comprehend now is the unimaginable shortening of distance that the railroad offered to western civilization in the 19th century. Trains pulling into the Lockland-Wyoming Station shortened travel time to Cincinnati from eight hours to less than one. Suddenly, Cincinnati was as close to Wyoming as it is today, and this area's attraction as a convenient residential community was firmly established. Wyoming's population before the 1840s was rural, the land owned exclusively by farmers. Industry on the canal attracted wealthy manufacturing executives to the area whose fine homes and extensive grounds brought a gentility and refinement to the countryside. After the trains arrived, the established farms near the tracks began to subdivide to accommodate white- and blue-collar commuters looking for building sites. In 1859, the area was still a community of only 45 people. In contrast, there were over 600 in 1873, most of those residents gained after 1865, when life and economics returned to normal after the costly Civil War.

The toll road had created Wyoming's first business district—where the old Spreen's Grocery building sits at the western end of Wyoming Avenue. That area served the steady traffic on the Hamilton, Springfield, and Carthage Turnpike. The railroad depot created a second business district near the tracks, and that one quickly outpaced the first. As a result, the land east of Springfield Pike developed as a village. Meanwhile, the area west of the pike remained rural, holding onto its farms and landed estates well into the 20th century, when the automobile finally replaced the train as America's preferred mode of travel.

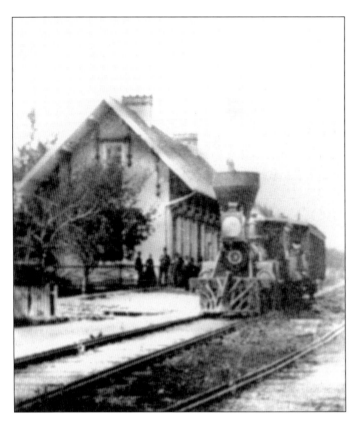

This photograph shows the Glendale Station with dual-gauge tracks. In 1869, the predecessor company to the Eric Railroad laid these six-foot tracks outside the single-gauge Cincinnati, Hamilton, and Dayton tracks. This connected the Erie's Dayton tracks with the Ohio and Mississippi tracks leading out of Cincinnati to New York and St. Louis. In 1888, standardized tracks were laid between Cincinnati and Hamilton. (Courtesy of Dan Finfrock.)

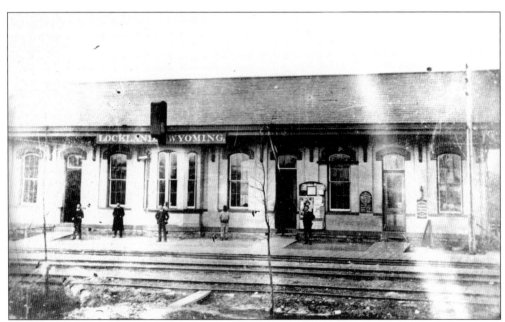

In 1847, the Cincinnati, Hamilton, and Dayton (CH&D) line started hauling freight through Wyoming. It was not until 1851 that passenger service started at the Lockland-Wyoming Station. (Courtesy of Dan Finfrock.)

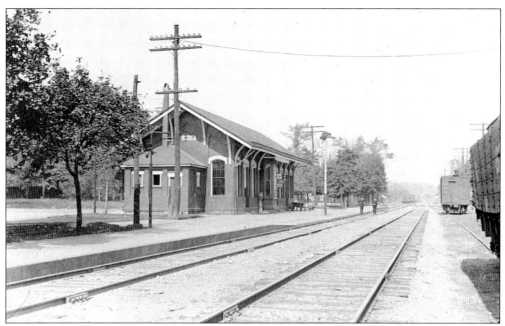

The Lockland-Wyoming Station, shown here around 1900, was the most popular station in Wyoming, and businesses located near it flourished. The Woodruff Building, built next to the station, housed a post office, the Wyoming Loan and Savings Company, a grocery and notion store, a dental office and several physician offices, a realty office, a seed mill, and a plumbing and tin shop. (Courtesy of the Wyoming Historical Society.)

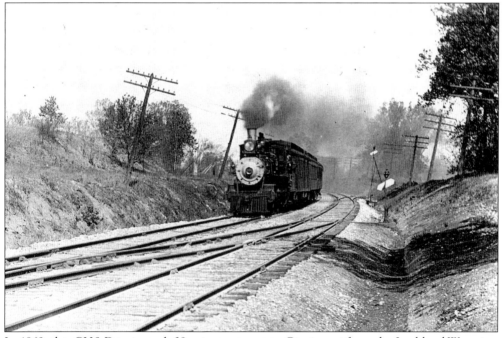

In 1869, this CH&D train took 39 minutes to get to Cincinnati from the Lockland-Wyoming Station. (Courtesy of Dan Finfrock.)

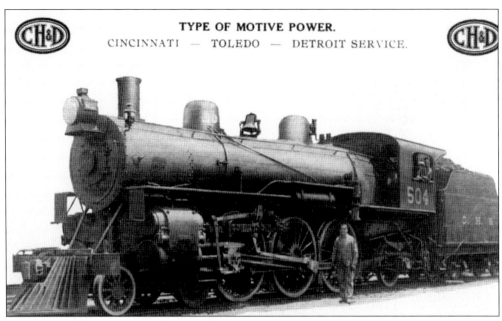

TYPE OF MOTIVE POWER.

CINCINNATI — TOLEDO — DETROIT SERVICE.

By the late 1800s, there were 19 trains like this CH&D going north through Wyoming each day. By this time, there were three stations in Wyoming, the main Lockland-Wyoming Station off of Crescent Avenue, Park Place Station to the north, and Maplewood Station on the Hartwell and Wyoming border. (Courtesy of John Diehl.)

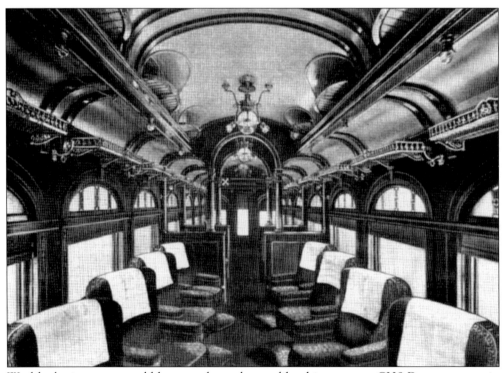

Wealthy businessmen would have used a parlor car like this one on a CH&D passenger train coming through Wyoming. (Courtesy of John Diehl.)

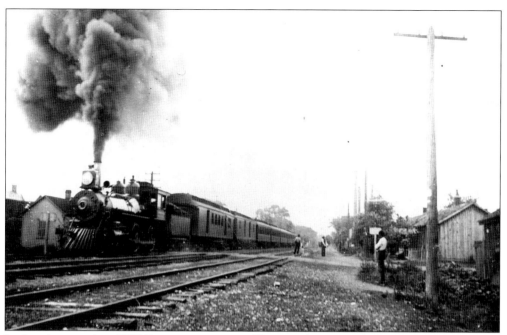

In this photograph, a CH&D train is crossing at Wentworth Avenue. (Courtesy of John Diehl.)

This CH&D ticket stub has been filled with punches. It was used by Marine H. Dubbs, a resident of Wyoming, in 1893. (Courtesy of John Diehl.)

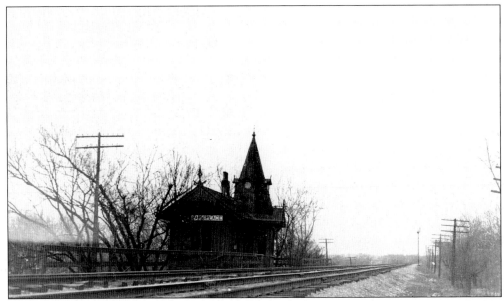

The Park Place Station was photographed in 1918. It was considered the most picturesque station on the line. The depot building had ladies' and gentlemen's rooms, a ticket office, and a baggage room. (Courtesy of Dan Finfrock.)

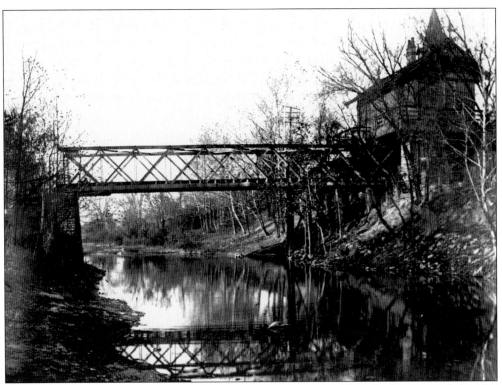

The Mill Creek ran behind Park Place Station. An 80-foot Howe Truss bridge spanned the Mill Creek and connected the station with the Park Place development to its west. (Courtesy of Dan Finfrock.)

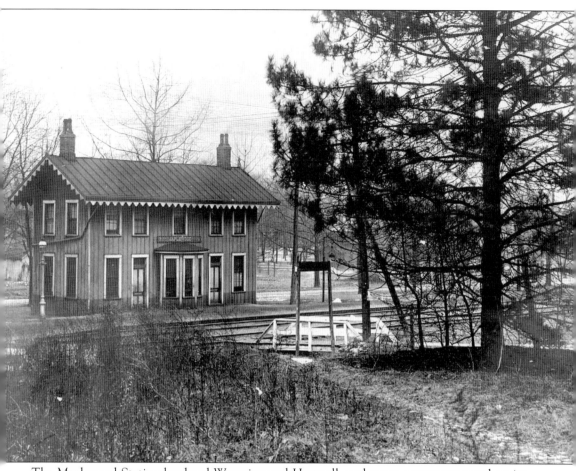

The Maplewood Station bordered Wyoming and Hartwell, and many commuters stood on its platform. By 1916, the CH&D ran 17 daily trains just going north along these tracks. (Courtesy of Dan Finfrock.)

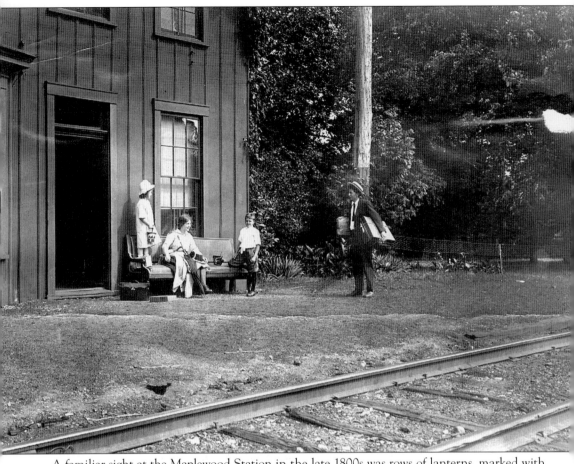

A familiar sight at the Maplewood Station in the late 1800s was rows of lanterns, marked with their owners' names, lined up on the platform for commuters to carry down unlit streets toward home. (Courtesy of the Wyoming Historical Society.)

Edgar Stark, a cashier working in Cincinnati, brought his family to Wyoming, where this photograph was taken in 1908. They were part of the early wave of commuters to make Wyoming their home. (Courtesy of John Diehl.)

Stark built this house at 18 Elm Avenue, and his wife remarked in a photo album of their Wyoming years, "The dearest spot on earth to me is 'Home, sweet home.'" (Courtesy of John Diehl.)

29

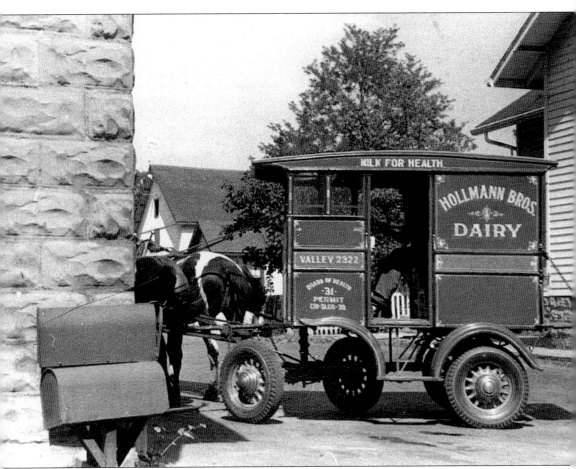

Wyoming farmers, like the later Hollmann Brothers Dairy, delivered milk as a way to serve the needs of commuters moving to Wyoming. (Courtesy of the Wyoming Historical Society.)

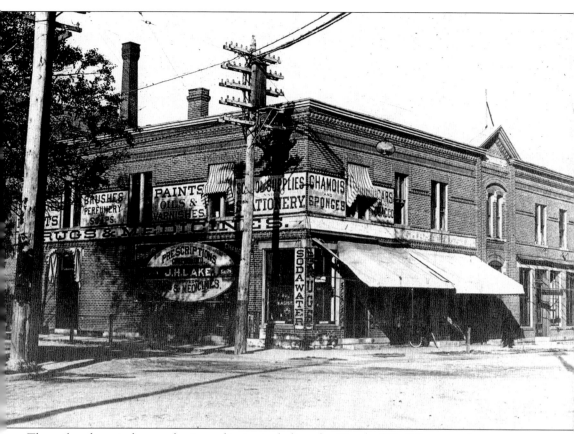

The railroad created a new business district including the Woodruff Building, seen here, near the Lockland-Wyoming Station as commuters, moving to and from the trains, shopped for their personal needs. (Courtesy of the Wyoming Historical Society.)

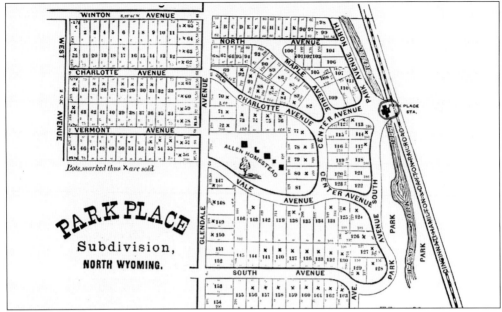

Glendale, a town north of Wyoming and one of the first planned suburbs in America, was so successful that speculators searched for more areas close to the rail line to develop. This Park Place subdivision site map, dated 1885, shows one such venture. The Park Place Land and Building Company, in developing the Allen farm on the northern edge of Wyoming, designed the homes for moderate incomes. (Courtesy of John Diehl.)

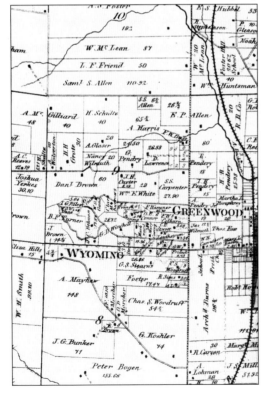

By 1869, this plat map for Springfield Township showed significant development along the tracks, as farmers began to sell off their land to developers. There was a turntable in Glendale, making that stop the last for many trains. Consequently, land south of Glendale was more valuable to developers. (Courtesy of the Public Library of Cincinnati and Hamilton County.)

Four

BECOMING
A COMMUNITY

On April 2, 1861, Robert Reily sent letters to the dozen families that lived in this rural settlement. They were invited to his home, Twin Oaks, for the purpose of naming this "embryo village," in his words, adding that "Ladies will be expected to participate." Those families gathered, just one week before the Civil War, and named their community Wyoming, the anglicized, and somewhat corrupted, version of the Delaware Indian word for "large plains"—*maughwanwame*.

After the Civil War, convenient train service made Wyoming a popular place to live for many professionals, who were moving away from Clifton and Mount Auburn and toward industrial development north of the city. A census taken in 1874 reported almost 600 people, predominantly Anglo-American, living in Wyoming, now an incorporated village. These early census records also showed German, Irish, and Italian families settled here. Ten percent of the population were African Americans, who had ridden a wave of emancipated people out of the South after the Civil War and found work on the railroads and in wealthy homes in the Mill Creek Valley.

Along with their belongings and aspirations, settlers carried many different expressions of worship into the Mill Creek Valley. The earliest organized churches in this area were in Reading and Lockland. The Swedenborgian Society, also known as the Church of the New Jerusalem, met in homes throughout the Mill Creek Valley. African American community members, finding travel difficult and white congregations unwelcoming, founded the first church in Wyoming in 1869.

Wyoming's incorporation in 1874 touched off a wave of church construction. The Presbyterian church, grown out of a Lockland congregation, had already built a simple frame structure in a cornfield by Wyoming Avenue in 1870. Prominent Baptist families purchased land from the Durrell farm and, in 1883, built the Victorian Gothic–style building that faces Burns Avenue. St. James of the Valley Roman Catholic Church was built near the railroad tracks in 1887 and opened a school by 1890. Episcopalians at first established the Church of the Ascension as a mission in 1893 and built their church after the financial panic of 1894.

Wyoming's existing farmland was now being sold quickly for land development. In the same year of Wyoming's incorporation, 45 acres of nearby land went on the market. Nine Wyoming men created the Wyoming Land and Building Company to purchase that tract, protecting the property from industrial use. This early control of land use allowed Wyoming to continue developing as a residential suburb, while businesses moved their operations to available, lower-taxed sites in Lockland, Carthage, and Elmwood.

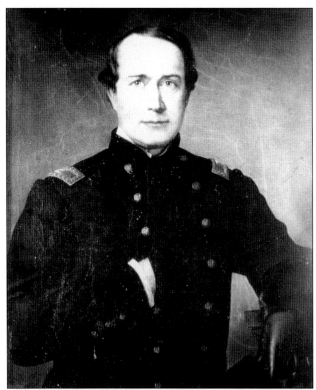

Robert Reily gave up a comfortable retirement in 1861 when war was declared on the Southern Confederacy. He helped Nathaniel McLean of Glendale organize the 75th Ohio Volunteer Infantry and became its commander by 1863. He fell at the Battle of Chancellorsville, Virginia, on May 2, 1864, and died of his wounds. Reily was buried at Spring Grove Cemetery, followed closely by his 19-year-old son Lt. James Reily, who died of an illness the same year. (Courtesy of the Wyoming Historical Society.)

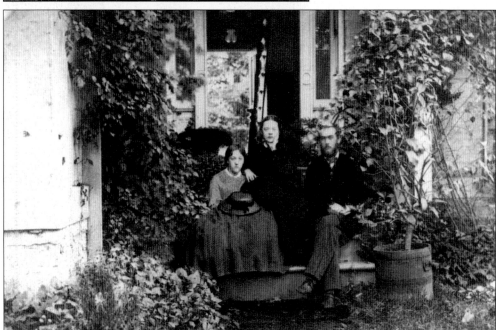

Members of the Reily family sit on the front porch of Twin Oaks for this photograph, taken in the 1860s. Isabella Gano Reily, Robert's wife, left Wyoming after her husband's and son's deaths and moved to Denver, Colorado, where she remained the rest of her years. (Courtesy of the Wyoming Historical Society.)

Brig. Gen. Jacob Ammen, "Uncle Jake" to his men, retired to Wyoming after a career as an officer in the army, teaching at West Point and fighting throughout the Civil War. He was stationed in Knoxville when he stopped "quasi-Union" men trying to smuggle provisions to the South. They would ask permission to bring hogs and salt across the Cumberland Gap and then conveniently get waylaid by rebels. Ammen dressed as a common soldier and joined the ranks of the "Union shriekers," as they called the traitors, to learn of their plans. (Courtesy of John Diehl.)

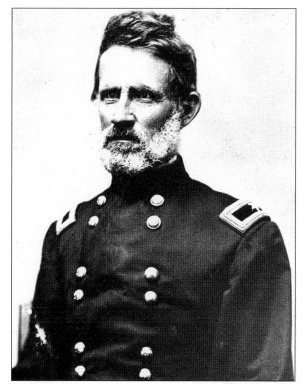

Ammen's Gothic Revival–style house at 229 Reily Road had its central gable until the 1960s, when a renovation transformed the 1860 frame Victorian into a French-style stucco residence. Two colonial-era barns from Vermont were built into the expansion. (Courtesy of the Wyoming Historical Society.)

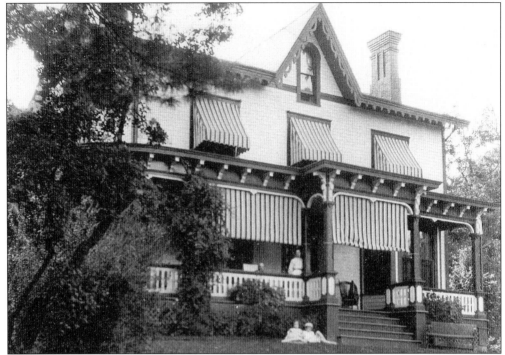

Another Gothic Revival–style home, the Cowing House at 320 Reily Road, faced down the hill to capture views of the valley. Estes Cowing built this home in 1860 for his wife and nine children. He continued to commute by train daily to his Cincinnati grain and produce business. It was in this house that ladies sewed a Union flag for the 75th Ohio Volunteer Infantry as they went to fight in the Civil War. The flag now hangs in the Wyoming City Council Chambers. (Courtesy of the Wyoming Historical Society.)

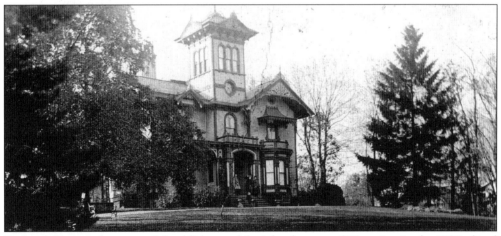

Roderick Barney, the successful publisher and farsighted mayor of Wyoming in the 1880s, lived in this house at 661 Glenway Avenue, originally built by Daniel DeCamp. Next door lived his brother, Howard; he and Roderick had married the wealthy Yates sisters from New Jersey. In the late 1880s, they shared in their front yards what might have been the first three-hole golf course in the Cincinnati area. Both houses have since been destroyed. Some of the property has been dedicated as Wyoming green space. (Courtesy of John Diehl.)

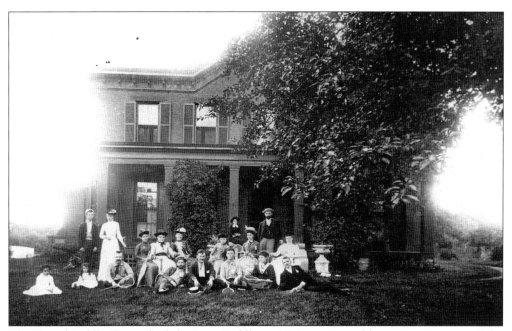

The Friend-Riddle House, built by Isaac Riddle in 1832, was owned by two generations of the George Friend family; Joseph Jewett, president of the Standard Pulley Company; and Ross Slonacker, owner of a lumber company and well known for his donations to the Cincinnati Art Museum. This house still stands at 507 Springfield Pike. (Courtesy of John Diehl.)

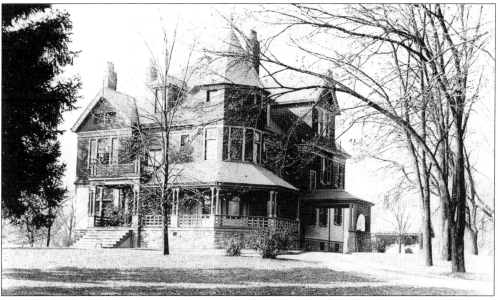

Josiah Kirby Sr. made his fortune by creating a "bung-making" machine, which made holes in beer barrels, a welcome invention for beer makers in Cincinnati. Like many industrialists, he also had wider business interests, including his involvement in two railroad ventures and service as president of the Cincinnati Board of Trade. During the Civil War, he equipped an entire regiment using his own funds. His home, shown here, still stands in Wyoming at 65 Oliver Road. (Courtesy of the Wyoming Historical Society.)

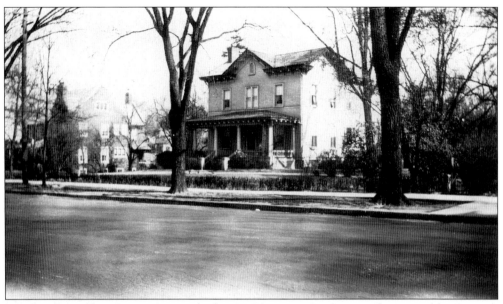

Another house that George Stearns built, 129 Wyoming Avenue, was first owned by Azaniah Compton in 1870. It presently retains most of the Victorian Italianate style seen in this early-1900s photograph. Subsequent owners added Tudor elements but kept its original barn, now used as a garage. (Courtesy of the Wyoming Historical Society.)

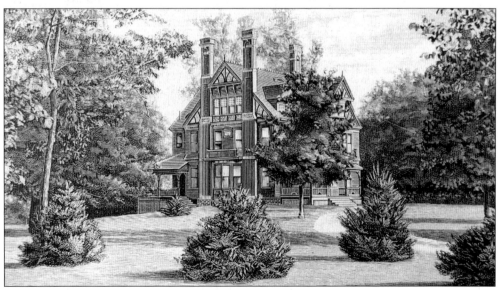

Sunnyside, the home of James Patterson Raymond, was featured, as were several other Wyoming estates, as a woodcut in D. J. Kenny's *Illustrated Cincinnati* in 1875. (Courtesy of John Diehl.)

Beech Avenue, tree-lined, looks today much like it did in this 1908 photograph. (Alice Firbank Foster photograph; courtesy of Frank and Nancy Foster.)

There were many small waterways in Wyoming in the early 1900s, like the stream this bridge crossed on Compton Road. A larger one ran from west of the Presbyterian church down through fields along where Grove Avenue cuts today. Another flowed south from Walnut Avenue, under Allen Avenue, and into Hartwell. The largest stream ran down the hill and through today's golf course, with a waterfall known as Beaver Falls. (Alice Firbank Foster photograph; courtesy of the Wyoming Historical Society.)

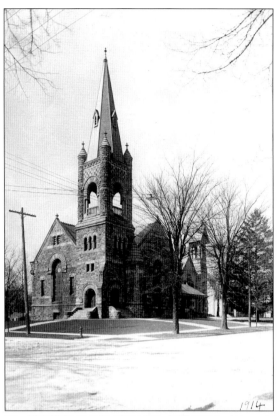

This photograph shows the Romanesque Revival–style Wyoming Presbyterian Church with the original white-framed church behind it on the right. After the new church, designed by the renowned architect Samuel Hannaford, was built in 1888, the frame building was used as a chapel. (Courtesy of the Wyoming Historical Society.)

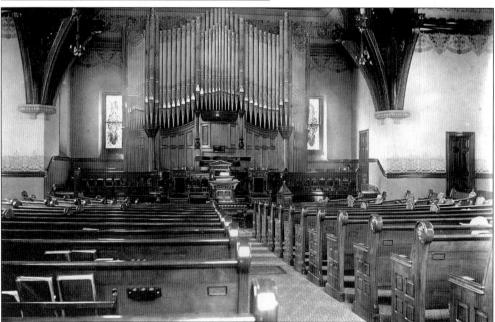

The stained glass windows behind the organ pipes, shown in this interior photograph of the Wyoming Presbyterian Church, were eventually removed, as was the original white-framed building, when the church was renovated in 1931. (Courtesy of the Wyoming Historical Society.)

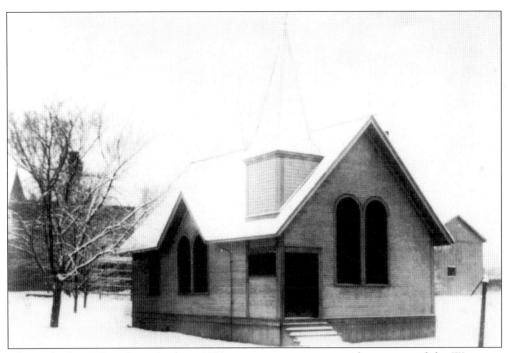

The Park Place Chapel was built in 1894 to encourage an outreach program of the Wyoming Presbyterian Church. Church member Elton Bogle had organized a sabbath school meeting at his house near Park Place for people living nearby that were unable to travel to the church, either for health or economic reasons. Grant H. Burrows encouraged members to fund the building of this little chapel. (Courtesy of the Wyoming Presbyterian Church.)

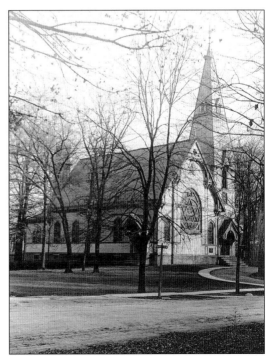

The deep forest that surrounded the Wyoming Baptist Church, photographed here in 1900, was known then as the Baptist Woods. Into those woods one early morning in the 1920s, the sexton followed a trail of blood that the organist had noticed outside a church window. He discovered the body of a man, a trespasser killed when his gun fell and discharged as he climbed through a window in the church. This Victorian Gothic church was built in 1882, designed by the well-known architect A. C. Nash. (Courtesy of the Wyoming Historical Society.)

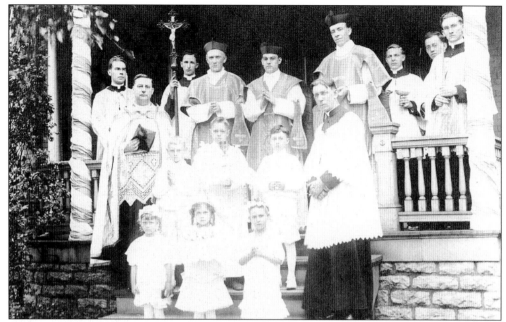

These first communicants stand outside the St. James rectory, which served as the school until one was built in 1912. (Courtesy of the St. James of the Valley Roman Catholic Church.)

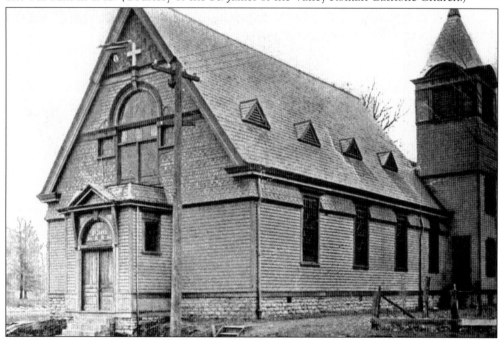

The first St. James Catholic Church grew out of a congregation in Reading and was built to serve Catholics in Wyoming, Hartwell, and Lockland. In 1890, only three years after the first church was built, it was expanded to accommodate a growing congregation, as is shown in this photograph. Eventually, the church moved to its Springfield Pike location, and the original property is now the site of the Wyoming Family Practice Center on Crescent Avenue. (Courtesy of the St. James of the Valley Roman Catholic Church.)

Charles Derrickson was an early African American pioneer in Wyoming and one of the founding members of the Maple Street Christian Church. Family member Julia Derrickson Cave attended the Wyoming schools for 12 years before working for them for another 48 years. Well-loved, she taught at both the Colony School and later at Wyoming Avenue, retiring in 1967. (Courtesy of the Wyoming Historical Society.)

African Americans, like the Stark family's servant seen here, often worked for the well-to-do living in Wyoming. These families started coming here in the 1870s, and many of their descendents still live in Wyoming today. (Courtesy of John Diehl.)

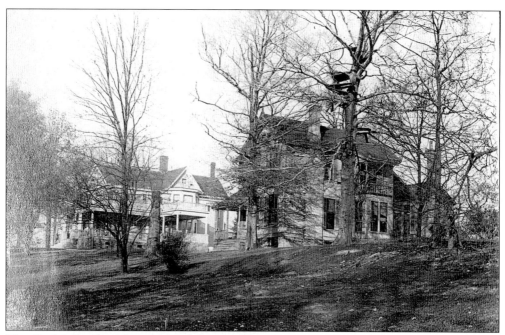

The Starks' daughter, homesick while on a European tour, received this photograph of her neighborhood on Elm Avenue in 1908. Her house at 18 Elm Avenue is in the foreground, and 50 Elm Avenue, home to the Ault family, is farther behind. (Courtesy of John Diehl.)

Judson Harmon was attorney general during Grover Cleveland's second presidential term and the governor of Ohio from 1909 to 1913. He had lived in Wyoming and, in 1882, made a grand speech at the 21st anniversary of its naming. In part, he extolled, "Wyoming . . . differs only in its suburban situation and charter so happily blending city and country that while we have not all advantages of either, we avoid most of the discomforts of both." (Courtesy of John Diehl.)

Five

THE MASTER PLAN

As the railroad moved people into the Cincinnati suburbs, Wyoming lost many of its farms to development and, as a village, began to participate in the civic and social bustle that characterized late-19th-century America. Mayor Jacob Bromwell offered a master plan for the village in 1881, proposing improvements that included an electric light plant, a new sewage system, new waterworks, new schools, and an amusement hall. The waterworks, constructed in 1892 with a brick pumping station, remains Wyoming's only industry today. A farsighted improvement was the laying of cement sidewalks, the first of any Ohio locality. These improvements were continued enthusiastically during Roderick Barney's mayoral administration. He led an 1892 celebration of the village, marked with a special train carrying dignitaries from Cincinnati and expansive speeches extolling the improvements and environs of this unique suburb.

With an increasing population of middle- and upper-class residents, recreational activities and social organizations flourished. The Wyoming Musical Club was formed in 1882, the Wyoming Dramatic Club in 1883, and the Wyoming Improvement Society in 1884. Matrons joined the Monday Club and the Society of Letters, which later converged into the current Wyoming Woman's Club. Young ladies collected books and formed a lending library in 1880, which eventually merged with the public library system of Cincinnati and Hamilton County 79 years later.

The success of the Wyoming Roller Rink in the Woodruff Building and the increasing number of social clubs looking for a place to meet inspired the community to plan a civic center. The Wyoming Amusement Hall Company organized the effort, raising almost $7,000 and constructing the Tudor-style building in 1885. The building included a mayor's office and council chambers and was often referred to as town hall.

In May 1907, the hall was completely destroyed by an early-morning fire. A new hall was built with public and private funds. The stately building, considered the largest in the village, was also destroyed by fire less than 50 years after its completion. Wyoming's current civic center was built one year later, in 1949.

In 1900, the City and Suburban Telegraph Association and Telephone Exchange established an exchange in this area at Dehmel's Pharmacy in the Woodruff Building. Calls were received at the store and, at a charge of 10¢ to the recipient, a young boy would run off to deliver the message. In 1909, the valley exchange was cut into service in Hartwell, and the old Wyoming office closed.

Dusty streets were a nuisance in neighborhoods, but the village, having just built its new waterworks, watered the streets regularly to keep the dirt down. (Alice Firbank Foster photograph; courtesy of Frank and Nancy Foster.)

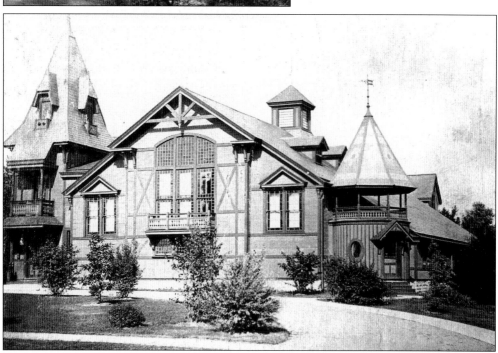

The Wyoming Amusement Hall, built in 1884 on the corner of Worthington Avenue and Springfield Pike, included the local library, two bowling alleys, tennis courts, and a roller rink made of maple flooring. The auditorium, with its balcony and 700-person seating, featured dances, fairs, and festivals. (Courtesy of the Wyoming Historical Society.)

The experimental well, driven by Mayor Roderick Barney, tapped an underground water supply that provided an almost unlimited amount of water. A high tank was erected to house the pumped water, and villagers built extra cisterns to fill with this new, valuable resource. (Courtesy of John Diehl.)

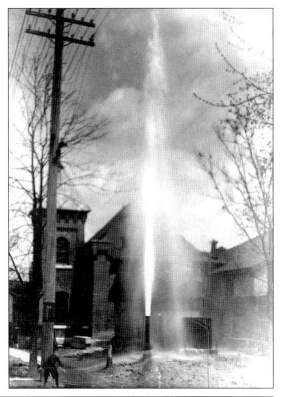

Reservoir Park was a popular destination for outings and buggy rides. The reservoir covered the flat area now holding the baseball field and playground near Hilltop School. The water basin was round and lined with concrete, and a small boat was tethered above the waterline for waterworks personnel. The tall wrought-iron fence that surrounded the basin was edged by a path worn down by running children and strollers. (Courtesy of the Wyoming Historical Society.)

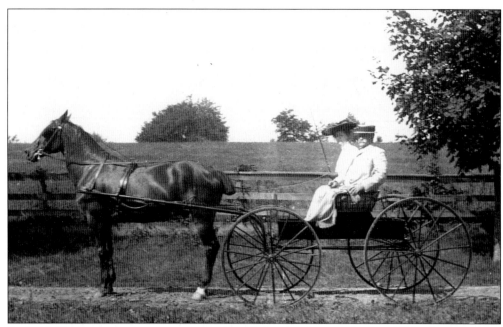

Roderick Barney was taking a carriage ride with his daughter in this late-1800s photograph. It was Barney who had studied the geology of the valley and concluded that it was the bed of an ancient lake, probably filled with sand. Over many arguments, his experimental well was driven at the amusement hall, and Wyoming still pumps water from the valley today. (Courtesy of John Diehl.)

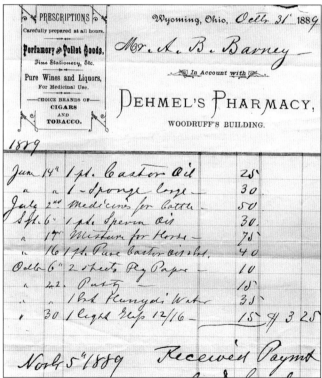

This Dehmel's Pharmacy receipt to Roderick Barney, dated 1889, shows purchases of drugstore items like castor oil and medicines for cattle but also included notions like a sponge, two sheets of flypaper, some putty, and window glass. Dehmel's Pharmacy was located in the Woodruff Building. (Courtesy of John Diehl.)

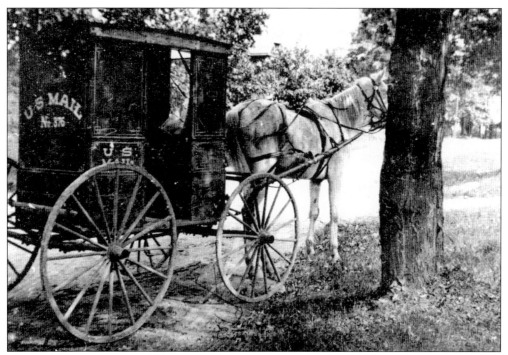

The mail buggy was, as one Wyoming lady wrote to her daughter, "a welcome visitor!" For many years, Charlie Slack operated the post office at the Woodruff Building, near the station where the trains dropped off mail sacks. (Courtesy of John Diehl.)

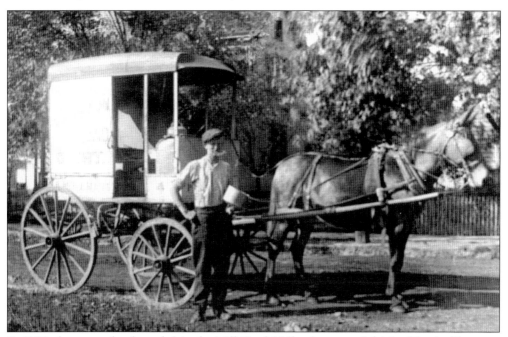

By 1900, there were few farms left in the Mill Creek Valley, but several dairies, like the Compton Road Dairy, remained in business, serving the commuter population around them. (Courtesy of the Wyoming Historical Society.)

This 1900 Wyoming Street is dirt, but the village's new cement sidewalks wind beside the roadway. The village laid over 12 miles of sidewalks by 1891. (Alice Firbank Foster photograph; courtesy of Frank and Nancy Foster.)

Bicycles were all the rage in the late 1800s and early 1900s. On Decoration Day (now known as Memorial Day), bicycle races started in Hamilton and passed through Wyoming before ending in Chester Park on Spring Grove Avenue. Villagers lined Springfield Pike to watch the cyclists, and young boys threw them lemon halves to quench their thirst. (Alice Firbank Foster photograph; courtesy of Frank and Nancy Foster.)

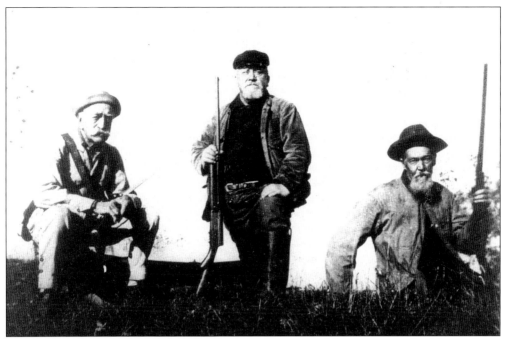

During the Civil War, southern Ohioans who were too old to serve in the Union Army volunteered to protect their neighborhoods and the city from rebel raiders like Gen. John H. Morgan. They called themselves the "Squirrel Hunters" because of their squirrel rifles and the fact that they were under no military authority and could justify their patrols with the innocent title. In this 1890 photograph, Joseph Jewett, Frank Stoddard, and a friend continue to patrol their Wyoming community long after the war's end. (Courtesy of Gene-Ann Good Cordes.)

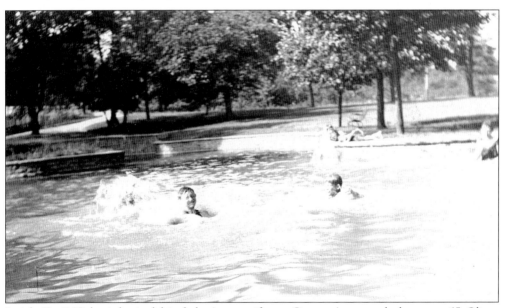

Josiah "Joe" Kirby inherited his father's magnificent Queen Anne–style home at 65 Oliver Road. In the early 1900s, he and his wife regularly invited village children to their swimming pool–sized pond to swim in the summer and skate in the winter. (Courtesy of John Diehl.)

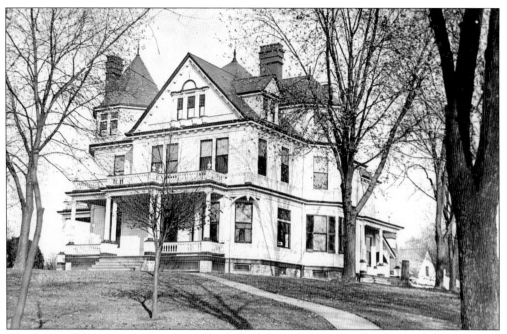

The Brownell house, now the site of Elm School, hosted the party that led to the founding of the Wyoming library. Initially, there were library membership dues of $2 a year, $10 for 10 years, and $25 for life. (Courtesy of the Wyoming Historical Society.)

Molly Wilson was one of the founding girls of the Wyoming library. The 24 young ladies each took charge of the books for two weeks; her assistant took charge after that. The library's hours were three afternoons a week at the girls' individual homes in town. Eventually, they moved the books to a room at the school and then to the Wyoming Amusement Hall when it was built. (Rephotographed by Barbara Gottling; courtesy of the Wyoming Historical Society.)

This pamphlet advertised the play *Twin Sisters*, which the girls put on to raise money for the library fund. They put on yearly programs, including the plays *Il Jacobie* (given on Stout's lawn at Twin Oaks) and *Last Will and Testament*. Their best fund-raisers were a "Pink Tea" (an afternoon tea just for ladies), raising $312, and the day they arranged a living chess game, which lasted so long the "chess pieces" complained of exhaustion. (Courtesy of John Diehl.)

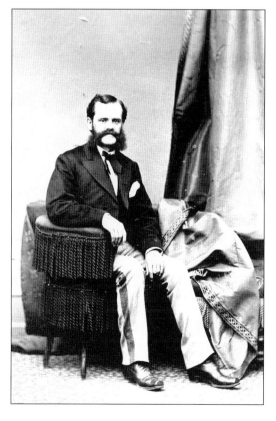

Roderick Barney, an executive for Robert Clarke Publishing and Booksellers, advised the girls on their purchases, helping them acquire an excellent collection of books. (Courtesy of John Diehl.)

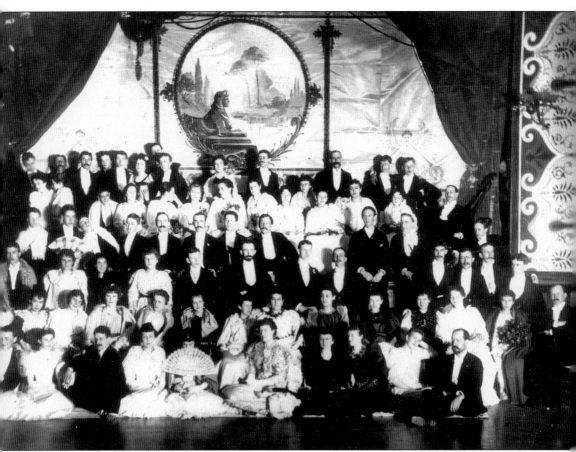

Villagers put on shows for their own amusement and entertainment, like this amusement hall stage presentation of Gilbert and Sullivan's *Mikado* in 1893 by the Wyoming Dramatic Club. Now the Wyoming Players, the club is the oldest-known amateur theatrical group in Ohio. (Courtesy of Gene-Ann Good Cordes.)

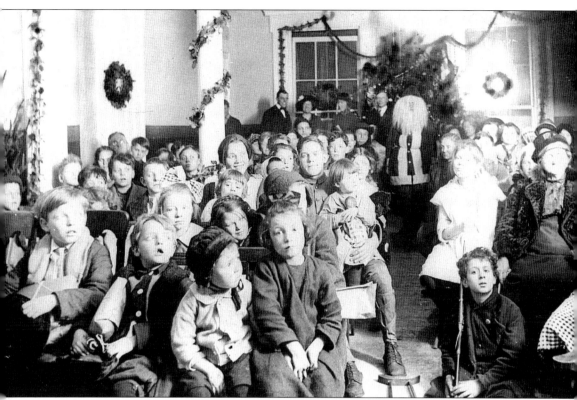

In this photograph of a 1915 Salvation Army Christmas program, Wyoming community members stand in the back of the room. Many community members, supported by their churches and other service organizations, have served the needy of Cincinnati and neighboring areas for many years. (Alice Firbank Foster photograph; courtesy of Frank and Nancy Foster.)

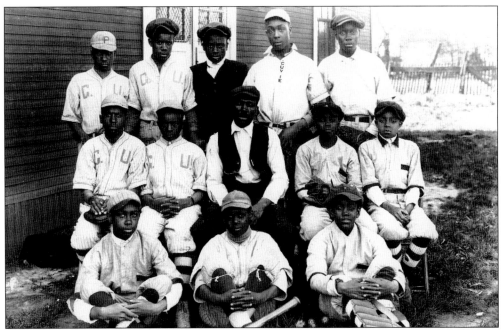

The Wyoming community sponsored numerous organized baseball teams, the first as early as 1869. These were all-white teams, however, but area African Americans developed their own teams, like the Glendale Umbrels pictured here, posing at the Wayne Avenue YMCA in 1921. Team members include Wilber Phillips, Sanford Wright, Arthur Moore Jr., Leroy Olverson, Allen Phelps, Steve Maxberry, Alfred Wright, Sam Phelps, George Olverson, Theodore Phelps, Jas Dorty, Elmer Harris, and Thomas Hays. (Courtesy of Joanne Pipes and the Wyoming Historical Society.)

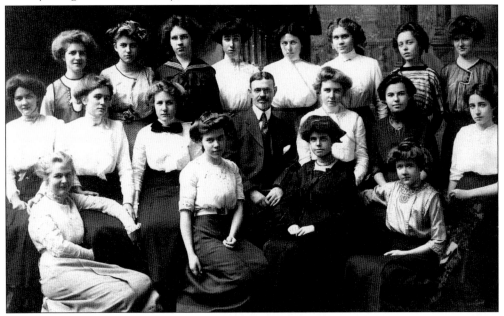

Edwards Ritchie's Sunday school class at the Wyoming Presbyterian Church was very popular in the early 1900s. (Courtesy of Kathryn Ellis Bond and the Wyoming Historical Society.)

Alice Firbank Foster, a native of England, followed her missionary husband around the world before settling in Wyoming. After his death, she worked as a social worker but also learned photography, developing an artistic talent for capturing the beauty in everyday life. (Courtesy of Frank and Nancy Foster.)

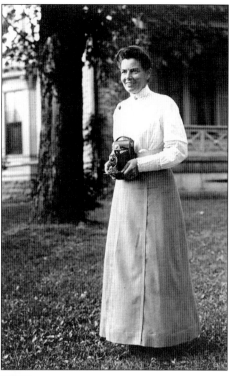

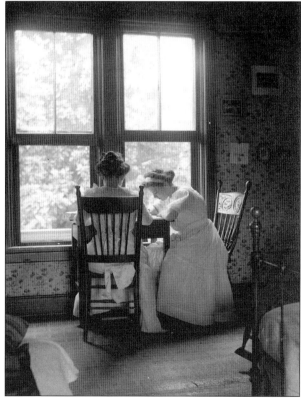

Alice Firbank Foster took this photograph of her daughters doing needlework by the window, catching the sunlight before the dimmer gaslights were lit. (Courtesy of Frank and Nancy Foster.)

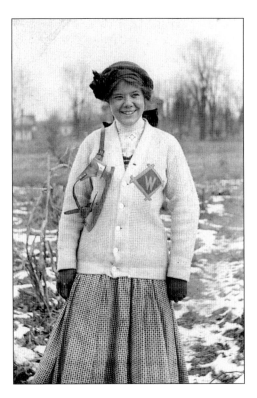

Polly Foster, Alice's daughter, poses in her Wyoming cardigan as she comes home from an ice-skating party on a nearby pond. (Alice Firbank Foster photograph; courtesy of Frank and Nancy Foster.)

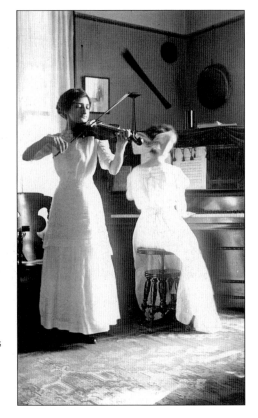

Homes in the upper-middle-class neighborhoods in Wyoming were filled with activities to "improve" oneself, like taking music lessons. (Alice Firbank Foster photograph; courtesy of Frank and Nancy Foster.)

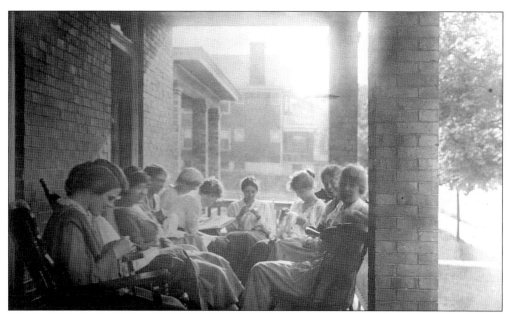

Porch parties were regular occurrences on sultry, summer days and evenings in Wyoming. (Alice Firbank Foster photograph; courtesy of Frank and Nancy Foster.)

During the progressive era, many churches took a greater interest in their children's religious education. The Presbyterian church's sabbath schools, mission bands, and Wyoming Junior Christian Education Society, shown here in party clothes in 1914, encouraged children to see social welfare outside the church walls. (Alice Firbank Foster photograph; courtesy of Frank and Nancy Foster.)

Charles Ault, shown here with his wife and family on their 50 Elm Avenue porch, owned a willowware company in Cincinnati. A relative, Levi Addison Ault, owner of the Ault and Wiborg Company, donated Ault Park to the city of Cincinnati. Charles Ault's wife, Susan, was the daughter of George George, who built many of the homes on Elm Avenue. (Alice Firbank Foster photograph; courtesy of Frank and Nancy Foster.)

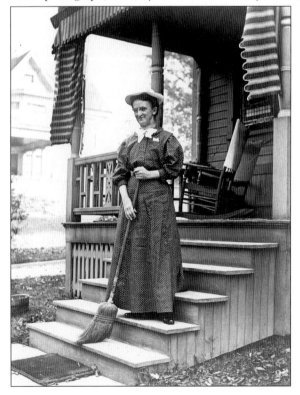

In this photograph, Mrs. Edgar Stark sweeps her porch, a daily ritual because of the dusty dirt streets. Once, the village decided to substitute crude oil for water as a longer-lasting solution to the dust problem, but it took several days to dry and tracked into every house and business. (Courtesy of John Diehl.)

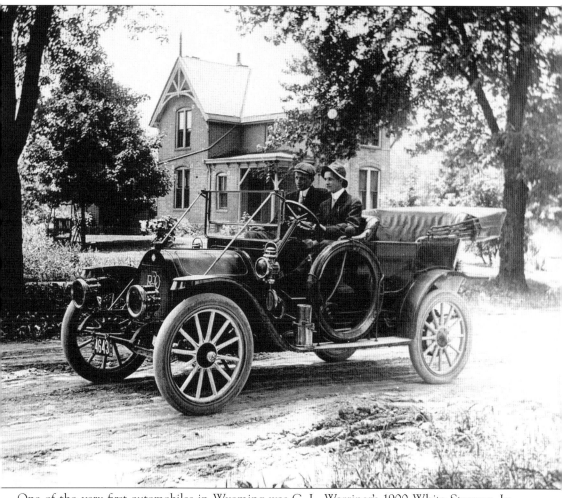

One of the very first automobiles in Wyoming was C. L. Warriner's 1900 White Steamer. In this 1908 photograph of Wyoming's automobile parade, C. A. Brownell is driving Don Smith by O. B. Schramm's home on East Mills Avenue. (Courtesy of John Diehl.)

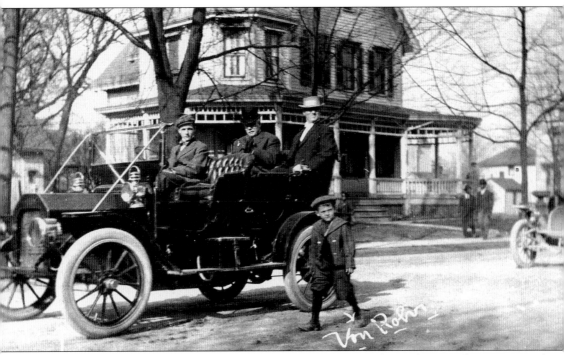

At the 1908 Wyoming Club Corner-stone Laying Ceremony, those who owned cars organized an automobile parade through town before the festivities. Pictured here is car No. 3 driven by C. A. Brownell with passengers W. Stearns in the derby hat and W. Peck. Dr. Hart's home at the northwest corner of Burns and Worthington Avenues is in the background. (Courtesy of John Diehl.)

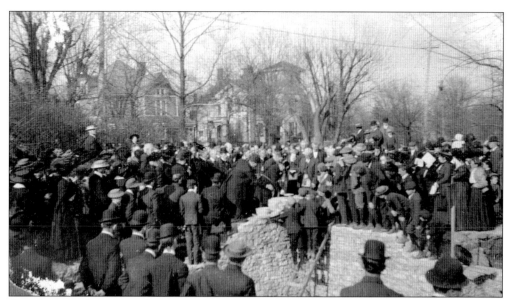

Crowds turned out for the Wyoming Club Corner-stone Laying Ceremony in 1908. Joe Kirby, Wyoming's mayor, had proposed building a new hall after fire destroyed the Wyoming Amusement Hall in 1907. He hosted a series of public meetings where funds could be collected, raising $6,000. The Wyoming Club raised another $18,000 with stock subscriptions. (Courtesy of John Diehl.)

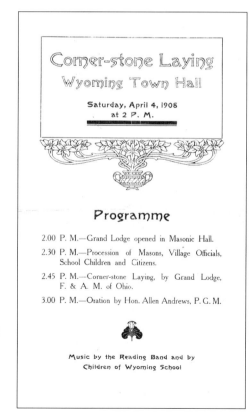

Corner-stone Laying
Wyoming Town Hall

Saturday, April 4, 1908
at 2 P. M.

Programme

2.00 P. M.—Grand Lodge opened in Masonic Hall.

2.30 P. M.—Procession of Masons, Village Officials, School Children and Citizens.

2.45 P. M.—Corner-stone Laying, by Grand Lodge, F. & A. M. of Ohio.

3.00 P. M.—Oration by Hon. Allen Andrews, P. G. M.

Music by the Reading Band and by Children of Wyoming School

This 1908 Wyoming Club Corner-stone Laying Ceremony program detailed the festivities of the day. The celebration was on the grounds of the former amusement hall, burned down the year before and soon to be rebuilt as the Wyoming Club. (Courtesy of John Diehl.)

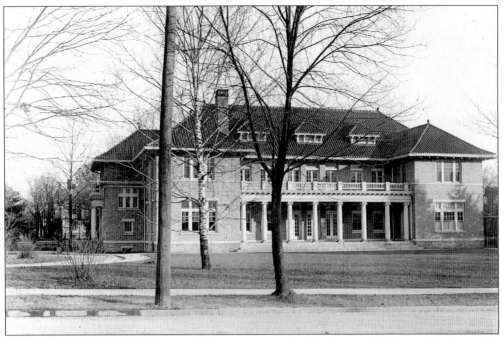

The Wyoming Club, shown here in 1908, was so new that landscaping had yet to be planted. It housed an auditorium and dance hall, a meeting hall, a cafeteria and dining room, four candlepin bowling alleys, the office of the Wyoming Building and Loan Association, and the Wyoming library. (Courtesy of the Wyoming Historical Society.)

Josiah "Joe" Kirby became Wyoming's 10th, and youngest, mayor, promoting the construction of the 1906 Town Hall and Fire Station, now the location of Sturkey's Restaurant. After losing his entire family inheritance over a failed land development venture in Wyoming, the young Kirby moved to Cleveland where his 50-year business career careened from wild success to controversy and failure. He organized the largest mortgage company in the United States, was elected commodore of the Cleveland Yacht Club, and forced a furious John D. Rockefeller to sell him his 17-story Cleveland building. But his precarious business dealings landed him convictions in state and federal trials for conspiracy, mail fraud, and market rigging and several terms in prison, his latest conviction occurring in his 80th year. (Souvenir Program, Carnival, and Circus of the Wyoming Club, 1906; courtesy of the Wyoming Historical Society.)

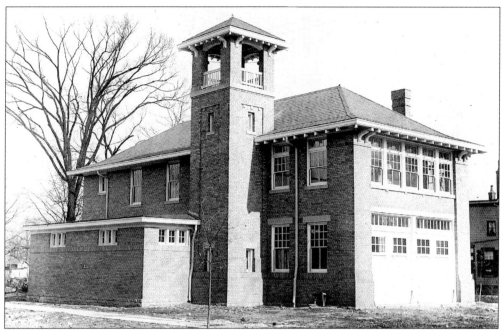

The Town Hall and Fire Station was another of Joe Kirby's expansive ideas. Suggesting that the village needed a new jail, the project expanded into new municipal offices, a fire department, council's chambers, and a recreation room for the firemen. After moving city facilities to the Colony School building and a new municipal services center on Grove Avenue, the former town hall was the board of education office before being remodeled as a restaurant. (Courtesy of the Wyoming Historical Society.)

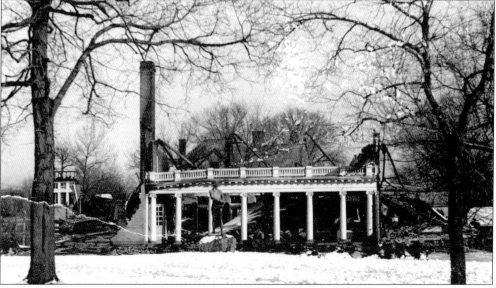

One winter night in 1948, the Wyoming Club burned to the ground. The flames were so high, only snow on neighboring roofs kept the fire from spreading down the block. Immediately, villagers made financial plans for a new civic center, which was built the next year. (Courtesy of the Wyoming Historical Society.)

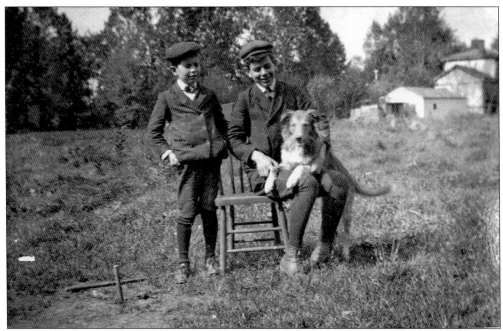

This pastoral view of East Mills Avenue, including her boys Ralph and Ted and their dog Nemo, was captured around 1910 by Alice Firbank Foster. (Courtesy of Frank and Nancy Foster.)

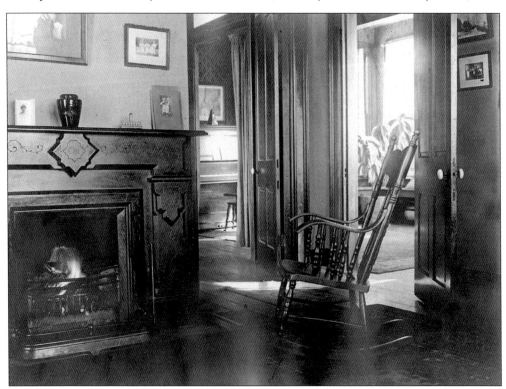

Alice Firbank Foster took this 1910 photograph of the parlor in her East Mills Avenue home. Many Wyoming families furnished their homes like this one during this era.

Six

School Days

The first officially recorded school in Wyoming was a one-room brick structure with whitewashed walls and hand-hewn woodwork, built in 1842. A portion of the Burns farm near the Hamilton, Springfield, and Carthage Turnpike was selected as the site for the new school. In time, the school was known as subdistrict No. 9 of Springfield Township, drawing children from Glendale to Carthage with the railroad as its eastern boundary.

The Wyoming School became its own district when the village incorporated in 1874. Six directors governed it under the county's jurisdiction, and its area conformed to the limits of the village. The new district levied taxes on real estate, acquired more acreage, and, in 1880, built a red-brick school facing Worthington Avenue, with outhouses, its own well, and coal stoves in every room. Fifty high school students paid tuition of $30 each and, in 1889, moved to a separate high school built on a corner of the large lot.

In 1873, school directors had voted to convert a house on Oak Avenue into a school for Wyoming's African American children, fostering a system of segregated education. Six years after the new school was built, however, Ohio repealed its Black Laws, and Wyoming abided by the state's abolition of segregated schools. In 1887, all African American children were transferred to the new school on Worthington Avenue.

When segregation was again allowed by the 1896 Supreme Court ruling of *Plessey v. Furguson*, the board of directors authorized the reopening of the Oak Avenue school in 1911 and built the Colony School. High school students remained desegregated, however, and attended the new school the village built in 1928, two years after it became an exempted school district. This new school, presently the Wyoming Middle School, was designed by the architectural firm of Hannaford and Sons. Its refined architecture reflects the formal Georgian style popular for school buildings of that day. In 1954, America began to desegregate its schools after the *Brown v. Board of Education* ruling. By then, Wyoming had desegregated its elementary schools with the opening of Vermont School the year before.

The school board, in an effort to accommodate the village's rapid growth after World War II, created a master plan to build neighborhood schools in the early 1950s. Vermont School was the first built in 1953, followed closely by Elm Elementary in 1955. Campuslike Hilltop School was next, built in 1958, and the last was the Pike School, built in 1961 and closed 20 years later because of low attendance levels. In 1967, the Pendery Avenue School opened, Wyoming's first freestanding middle school. The school was two years old when it was redesigned as a high school.

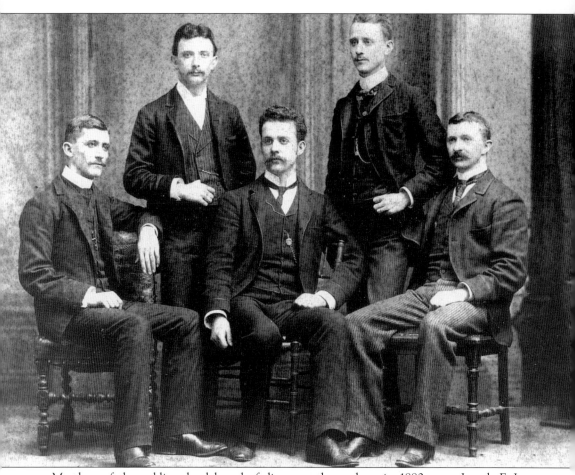

Members of the public school board of directors, shown here in 1880, were Joseph F. Jewett (center), R. H. Andrews, Grant Burrows, J. H. Pendery, and J. H. Thorton. (Courtesy of Gene-Ann Good Cordes.)

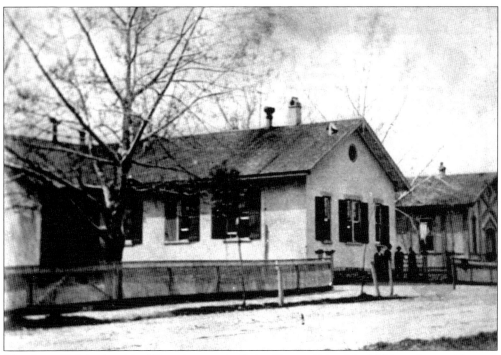

The first official school in Wyoming was built by George Friend in 1842, and two girls were its first students. Over the next 40 years, two wings were added as the area's population grew. (Courtesy of the Wyoming Historical Society.)

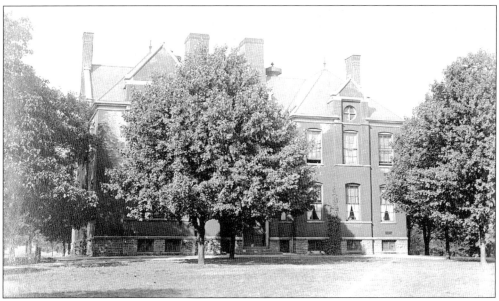

When trustees considered building a new school on Wyoming Avenue in the 1870s, G. H. Burrows strongly recommended that additional land be purchased, envisioning a larger village population than others imagined. The board purchased a tract of land extending from Wyoming Avenue to Worthington Avenue, and this eight-room village school was built in 1880. (Courtesy of the Wyoming Historical Society.)

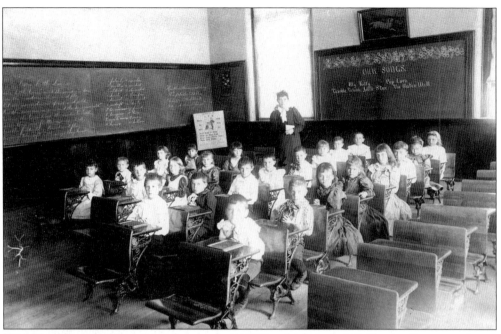

Kitty Gould taught Wyoming's first grade in 1892, which included Charles Sawyer, a future United States secretary of commerce. (Courtesy of John Diehl.)

Gantvoort's School Music Reader was one type of study book used by Wyoming students in their curriculum. In 1910, electives like music, art, and domestic science were added but only on a part-time basis. (Courtesy of John Diehl.)

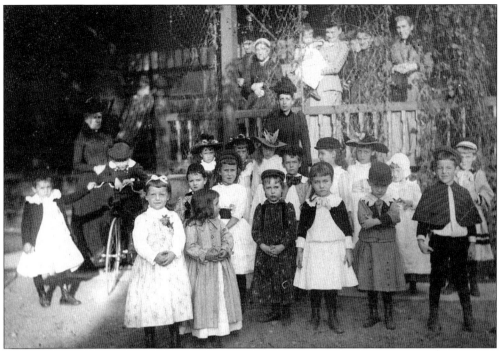

Miss Chase's nursery school, gathered here in 1889, reflected both the community's wealth and its strong interest in early education. (Courtesy of John Diehl.)

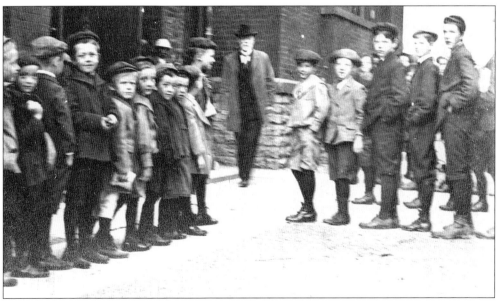

In 1874, Charles Sherman Fay was appointed Wyoming's first principal/teacher—both principal and superintendent. An excellent educator, he established a challenging curriculum at Wyoming. He was also well respected by his students, like these outside the grammar school, who called him "Daddy" and, later, "Granddaddy" Fay. (Courtesy of John Diehl.)

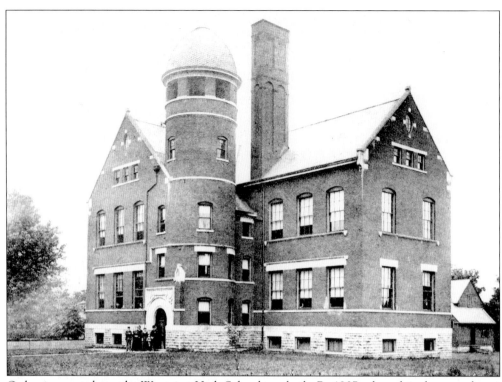

Only nine years later, the Wyoming High School was built. By 1907, when this photograph was taken, it had inside plumbing and central heat. (Courtesy of the Wyoming Historical Society.)

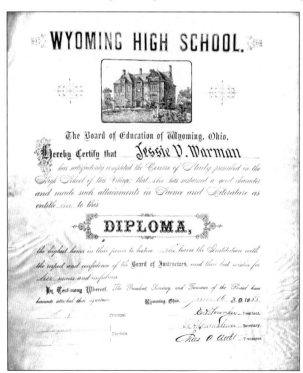

This is the first Wyoming High School diploma, made out to Jessie V. Warman in 1885. Five students graduated in this first senior class. (Courtesy of John Diehl.)

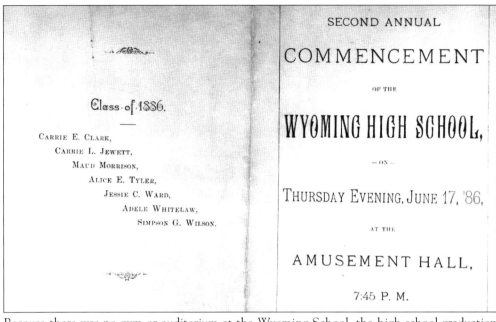

SECOND ANNUAL

COMMENCEMENT

OF THE

WYOMING HIGH SCHOOL,

— ON —

THURSDAY EVENING, JUNE 17, '86,

AT THE

AMUSEMENT HALL,

7:45 P. M.

Class · of · 1886.

CARRIE E. CLARK,
CARRIE L. JEWETT,
MAUD MORRISON,
ALICE E. TYLER,
JESSIE C. WARD,
ADELE WHITELAW,
SIMPSON G. WILSON.

Because there was no gym or auditorium at the Wyoming School, the high school graduation program in 1885 was held at the Wyoming Amusement Hall, as it would be for many years. (Courtesy of John Diehl.)

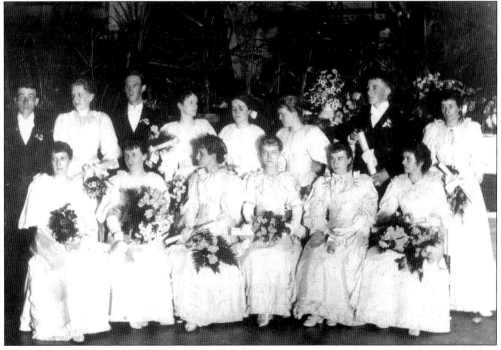

The graduating class of 1893 was photographed with its young women in white gowns, which is still a tradition, and diplomas rolled up and tied with ribbons. High school students came not just from Wyoming but also from old subdistrict No. 9, which included Hartwell and Woodlawn. (Courtesy of Gene-Ann Good Cordes.)

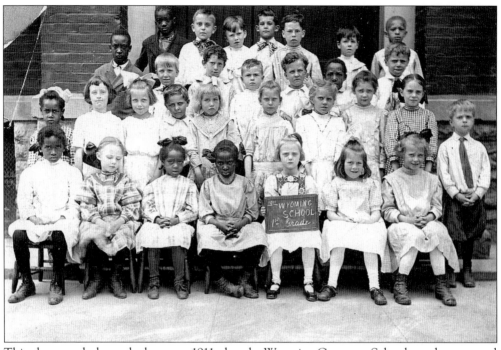

This photograph shows the last year, 1911, that the Wyoming Grammar School was desegregated until the early 1950s. (Courtesy of the Wyoming Historical Society.)

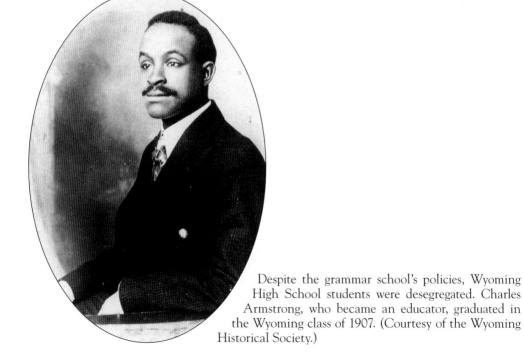

Despite the grammar school's policies, Wyoming High School students were desegregated. Charles Armstrong, who became an educator, graduated in the Wyoming class of 1907. (Courtesy of the Wyoming Historical Society.)

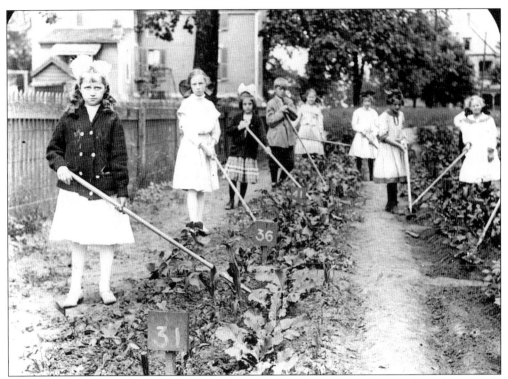

Wyoming schools encouraged students to learn outside of the standard curriculum. An example was this grade school garden project in 1913. (Alice Firbank Foster photograph; courtesy of Frank and Nancy Foster.)

The Colony School was opened in 1912 for Wyoming's African American elementary students. It closed in 1955, served as a YMCA, and is now the municipal building for the city of Wyoming. (Courtesy of the Wyoming Historical Society.)

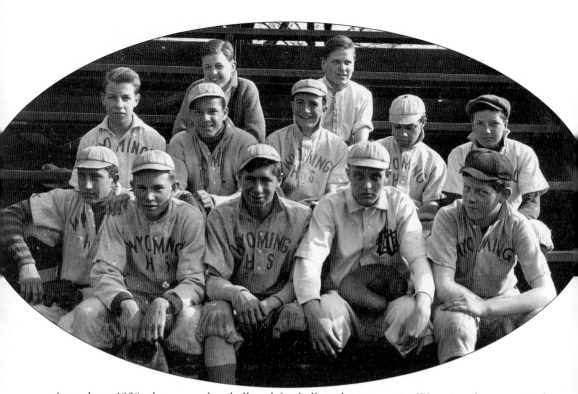

As early as 1908, there were baseball and football student teams in Wyoming, but organized sports were not official school functions. Between 1910 and 1916, Wyoming High School took on the responsibility of football, track, and baseball, including the 1913 baseball team shown here. (Courtesy of the Wyoming Historical Society.)

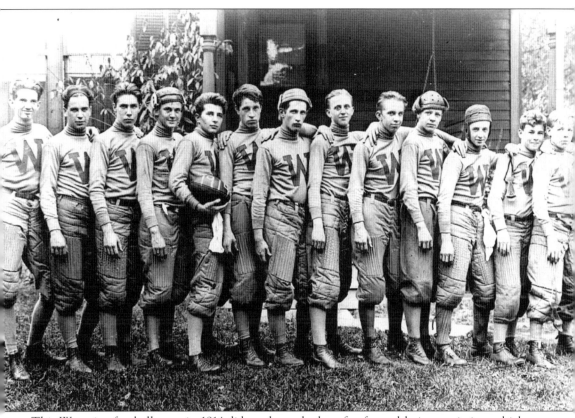

This Wyoming football team in 1914 did not have the benefit of an athletic association, which was not formed until 1916. By 1919, the school furnished jerseys and pants for members of the football team, and games were played at the old athletic field on the east side of Springfield Pike between Wilmuth and Pendery Avenues. (Courtesy of the Wyoming Historical Society.)

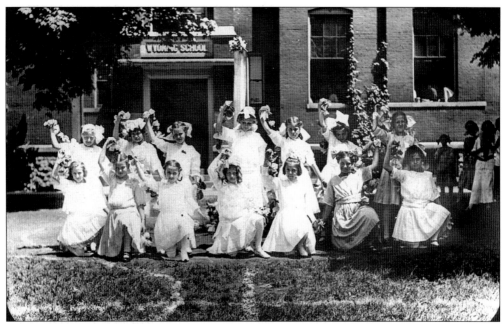

Wyoming May Day, celebrated here in 1914, started as a spring ceremony with a May Queen in white, the dress made from old white lace curtain panels. Over the years, a king was added, then runners-up, and finally a court of 30 elementary students preceding the royal couple. (Alice Firbank Foster photograph; courtesy of the Wyoming Historical Society.)

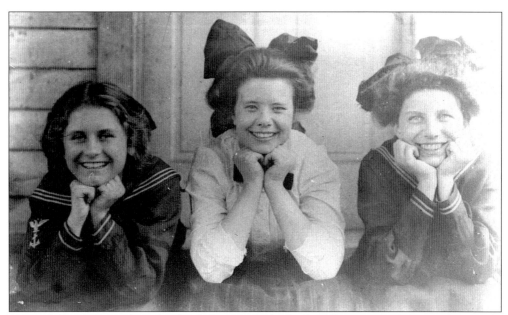

Pictured from left to right, school girls Lucetta Sutherland, Polly Foster, and A. Knight pose for Polly's mother in this photograph from the second decade of the 1900s. (Alice Firbank Foster photograph; courtesy of the Wyoming Historical Society.)

There were only four members of the Wyoming High School faculty, including Charles Fay, before the new school was built in 1928. (Courtesy of the Wyoming Historical Society.)

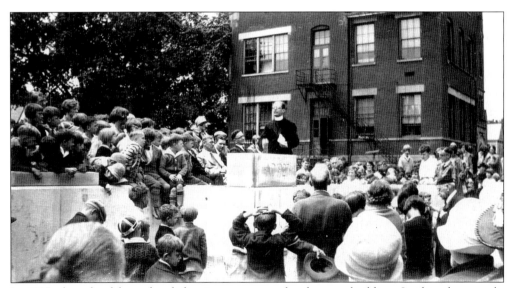

In 1927, the school hosted a dedication ceremony for the new building. In this photograph, Episcopalian minister Reverend Stridsburg leads a prayer during the event. (Courtesy of the Wyoming Historical Society.)

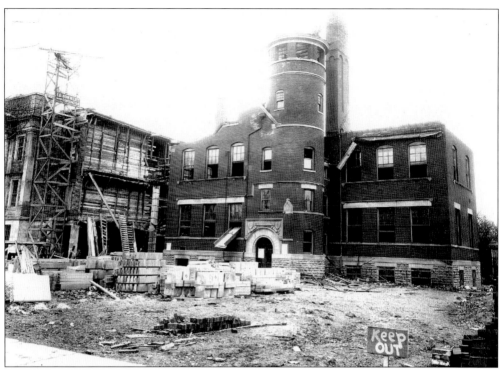

The east wing of the new Wyoming School was built first, and the high school grades were moved there. This photograph shows the old high school being demolished to make room for the west wing. (Courtesy of the Wyoming Historical Society.)

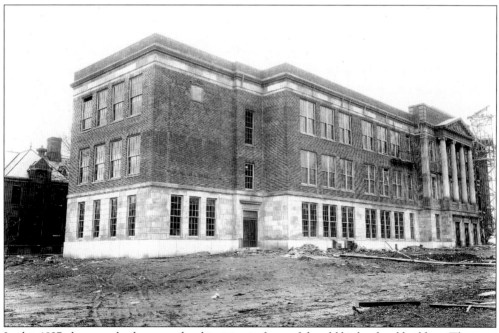

In this 1927 photograph, the new school is rising in front of the old high school building. This new school is currently the Wyoming Middle School. (Courtesy of the Wyoming Historical Society.)

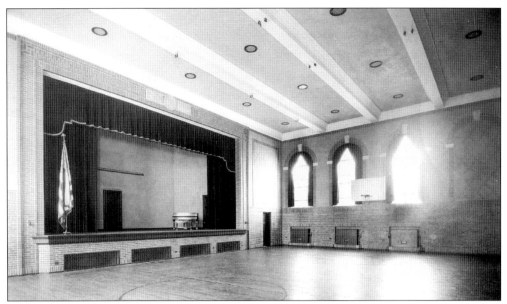

A school auditorium and gymnasium had been long wanted by the community, but a bond issue of $400,000 was delayed until after the Great War years of 1917–1919. The Wyoming Parent-Teacher Association was instrumental in passing that bond. (Courtesy of the Wyoming Historical Society.)

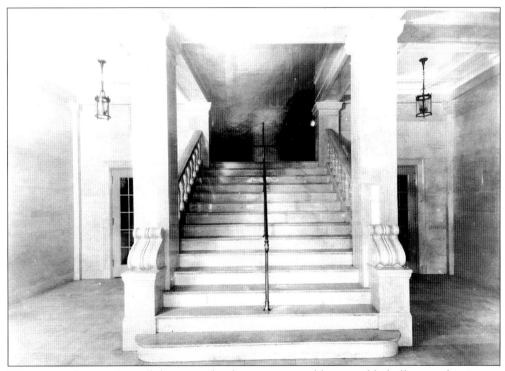

The east and west wings of the new school were separated by a marble hallway and staircase, which was off-limits to all students except on special occasions, like the Christmas tree lighting and program each year. (Courtesy of the Wyoming Historical Society.)

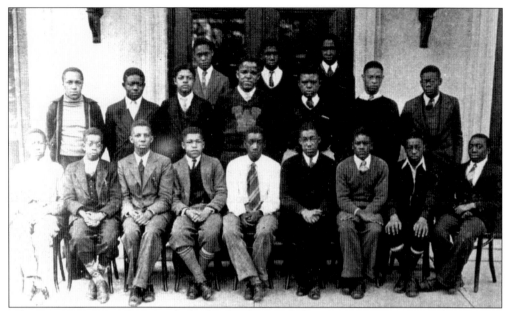

African American students at the high school formed their own social organizations, like the Colored Hi-Y, in 1933. Although students mingled in the classroom and in some sports, there was little socializing between whites and blacks at the school during this time. (Courtesy of the Wyoming Historical Society.)

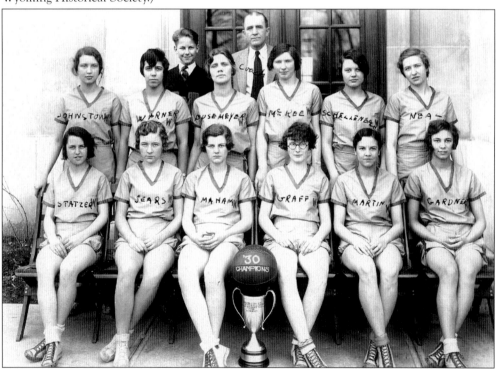

It was not until 1929, when the new school provided a gymnasium, that basketball was offered. This 1930 girls' basketball team was the champion for the Hamilton County Athletic Association. (Courtesy of the Wyoming Historical Society.)

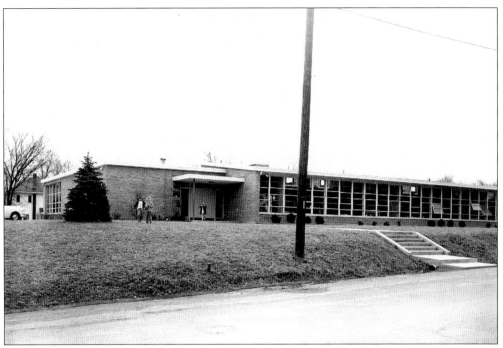

Vermont School, opened in 1953, was the first of Wyoming's neighborhood schools to be built. (Courtesy of the Wyoming Historical Society.)

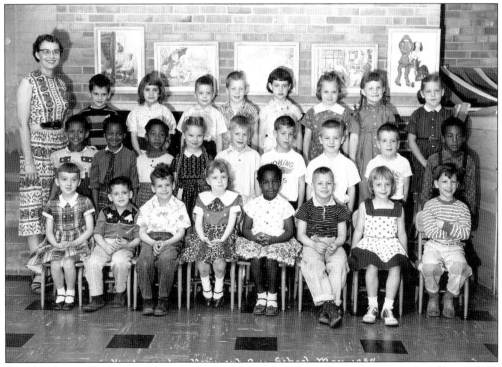

This kindergarten class at Vermont School, shown with teacher Marguerite Breyley in 1959, shows an integrated classroom. (Courtesy of the Wyoming Historical Society.)

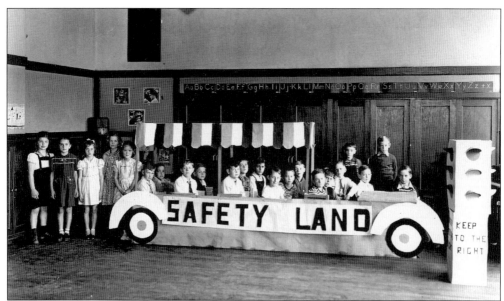

During the 1950s, classrooms across America, like this one in Wyoming, began to teach street safety and hygiene, in addition to traditional subjects. (Courtesy of the Wyoming Historical Society.)

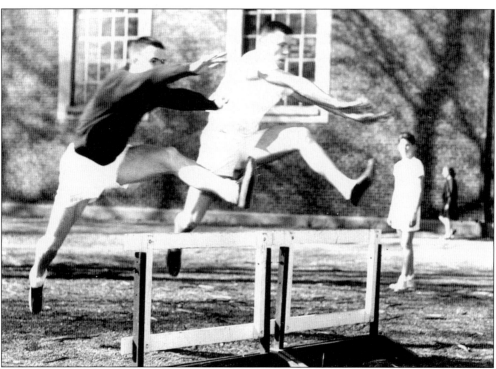

Wyoming sports teams, including the track-and-field team shown here in the 1950s, were known as the Cowboys. That name was adopted in the 1930s, given the Western reference in the village's name. Following that theme, the yearbook changed its name to *Round Up* in 1941. The school colors, originally blue and gold, were changed to blue and white in the early 1960s. (Courtesy of the Wyoming Historical Society.)

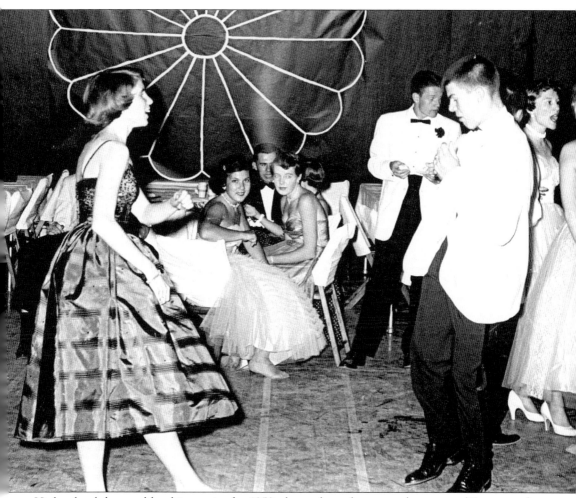

High school dances, like this one in the 1950s, have always been popular events. (Courtesy of the Wyoming Historical Society.)

The high school graduating class of 1956 sang that year's version of the school's anthem: "Wyoming, Wyoming, calling me home. Wide open spaces where I love to roam. Green valleys, kissed by the sun—Deep purple covers you when day is done. In Wyoming, I'm sure to find; perfect contentment and sweet peace of mind. When my roving's over, and you're deep in clover, I know there'll be someone to welcome this rover to my Wyoming." (Courtesy of the Wyoming Historical Society.)

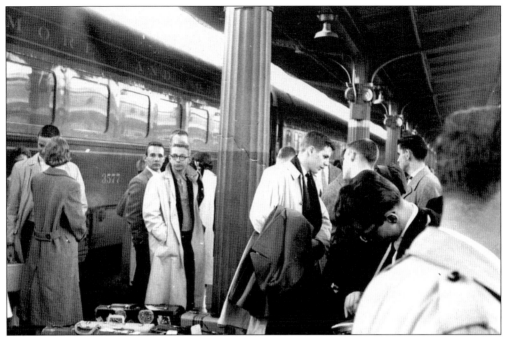

The senior class at the high school makes a traditional trip to Washington, D.C., every year. Here is a class in the 1950s boarding a train at Union Station in Cincinnati for the trip. (Courtesy of the Wyoming Historical Society.)

During a Washington, D.C., field trip in 1972, the Wyoming senior class poses with Pres. Richard Nixon for an official photograph on the White House steps. (Courtesy of the Wyoming Historical Society.)

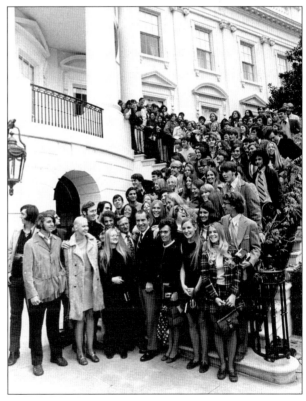

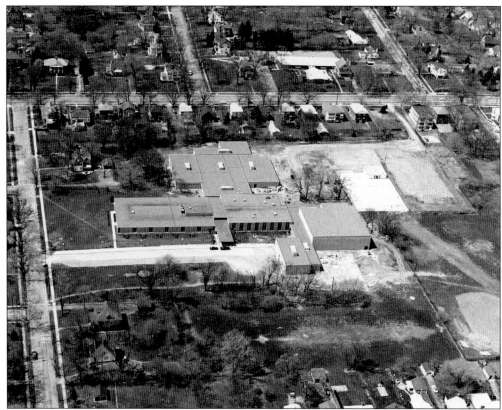

The new middle school had just been built, shown in this aerial photograph, when the school board decided to remake the building into a high school and transfer populations. (Courtesy of the Wyoming Historical Society.)

Hilltop School was built in 1956 and is the largest of the elementary schools in Wyoming. (Courtesy of the Wyoming Historical Society.)

May Fete began as a Valentine fete in 1922 and earned $101 for the Mother's Club, which they used for school needs. Eventually, the need to move the party outside and inclement weather in February changed the traditional date to May. May Fete continues to earn significant funds for the Parent Student Association and the school system. (Barbara Gottling photograph; courtesy of the Wyoming Historical Society.)

The Wyoming Homecoming Parade is a school tradition; classes and organizations build competing floats, as is happening here in 1999. (Courtesy of the Wyoming Historical Society.)

Seven

PRESERVING THE PAST

In 1901, electric streetcars, part of the Mill Creek Line, first ran through Wyoming, and before the trolley era ended 30 years later, streetcar transportation would make a substantial mark on the architecture and population of Wyoming. Inexpensive streetcar transportation allowed Cincinnati's middle class to gain commuter access to an area previously reserved for those able to purchase train tickets. Affordable housing was encouraged in land development. Simple cottages, arts and crafts–inspired bungalows, and Colonial Revival–style homes appeared along newly laid streets radiating from the village.

In the early 1900s, Wyoming created a zoning board and planning commission to monitor the development of the village, tracking and controlling land use under strict zoning laws. Upon incorporating as a city in 1949, Wyoming annexed land west of the Springfield Pike, developed adjacent farmlands, and increased tax revenue to cover the expanding costs of city and school operations. In 1960, Wyoming detached from Springfield Township, making itself a separate township. This action, coupled with the establishment of a separate school district in 1926, gave Wyoming residents a high degree of control over their suburban environment.

New populations arriving in Wyoming after World War II added expressions of worship to the community. The First Church of the Christ, Scientist began worship services in Wyoming in 1946, and the stately, Federalist-style church was dedicated 10 years later. Friendship Methodist Church began as a pioneering congregation that built a church in Lockland in 1874 and, by 1960, had moved to Wyoming. An influx of Jewish community members in the 1950s, meeting first in private homes, led to the opening of the Valley Temple on Springfield Pike in 1974. Finally, the People's Baptist Church, now Messiah Community Church, on Burns Avenue, organized by a small congregation, opened the doors to its new church building in 1965.

The city of Wyoming enjoys its reputation as a quiet community of historic homes with a variety of 19th- and early-20th-century architectural styles because of concerted historic preservation efforts in the 1970s and 1980s. After World War II, young families chose to live in new developments in the Wyoming hills west of Springfield Pike. Housing in the village fell into decline, and several significant buildings were destroyed, including the Lockland-Wyoming train station and the Woodruff Building. By the 1970s, however, young professionals began to revitalize the village area. Community efforts led to the placing of the Wyoming Historic District and other individually significant homes on the National Register of Historic Places in 1986.

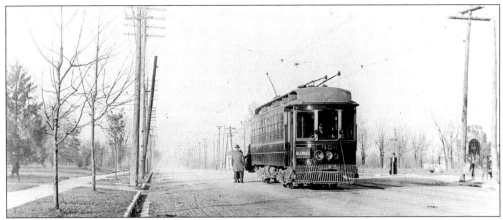

In 1864, the Cincinnati Street Railway began as a single-track horsecar in the city. The line changed company names over the years, becoming the Main Street Passenger Railroad, then the Mount Auburn Street Railroad Company, and, in 1873, the Cincinnati Inclined Plane Railway. That company, in 1888, installed electric lines to power 18 new electric streetcars on the railway. Despite legal battles over revenues with the City of Cincinnati, the streetcars reached Lockland after a new bridge over the Mill Creek was built in 1898. In 1901, the Cincinnati, Glendale, and Hamilton Electric Railway ran its first car, like the one pictured, through Wyoming, going as far north as Glendale and eventually ending the line in Hamilton. (Courtesy of the Wyoming Historical Society.)

GLENDALE CARS
Arriving at North Corporation Line of Wyoming as follows:
INBOUND

WEEKDAYS		SATURDAY		SUNDAY	
A.M.	P.M.	A.M.	P.M.	A.M.	P.M.
5:43	3:33	5:43	2:43	6:03	8:03
6:03	4:03	6:03	3:03	6:33	8:33
6:18	4:33	6:18	3:23	7:03	9:03
6:33	5:03	6:33	3:43	7:33	*9:33
6:48	5:33	6:48	4:03	8:03	10:03
7:03	*5:43	7:03	4:23	8:33	10:33
7:18	6:03	7:18	4:43	9:03	11:03
7:33	*6:13	7:33	5:03	9:33	*11:28
7:48	6:33	7:48	5:23	10:03	*11:58
8:03	*6:43	8:03	5:43	10:33	*12:28
*8:08	7:03	*8:08	6:03	11:03	*12:58
8:33	7:33	8:33	6:23	11:33	*1:25
*8:43	8:03	*8:43	6:43	P.M.	
9:03	8:33	9:03	7:03	12:03	
*9:13	9:03	*9:13	7:33	12:33	
9:33	9:33	9:33	*7:33	1:03	
10:03	10:03	10:03	8:03	*1:03	
10:33	*10:03	10:33	8:33	1:33	
*10:33	10:33	*10:33	*8:33	2:03	
11:03	11:03	11:03	9:03	2:33	
11:33	*11:28	11:23	*9:08	3:03	
P.M.	*11:58	P.M.	9:33	4:03	
12:03	*12:28	12:03	10:03	4:33	
12:33	*12:58	12:23	10:33	5:03	
*12:33	*1:25	12:43	11:03	5:33	
1:03		1:03	*11:28	6:03	
1:33		1:23	*11:58	6:33	
2:03		1:43	*12:28	7:03	
2:33		2:03	*12:58	7:33	
3:03		2:23	*1:25		

GLENDALE CARS
Arriving at South Corporation Line, Mills Avenue, Wyoming, as follows:
OUTBOUND

WEEKDAYS		SATURDAY		SUNDAY	
A.M.	P.M.	A.M.	P.M.	A.M.	P.M.
x5:10	3:25	x5:10	2:15	x5:30	6:55
x5:30	3:55	x5:30	2:35	x6:00	7:25
x5:45	4:25	x5:45	2:55	x6:30	7:55
x6:00	4:55	x6:00	3:15	x7:00	8:25
x6:15	5:10	x6:15	3:35	x7:30	8:55
x6:30	5:25	x6:30	3:55	7:55	9:25
6:35	5:40	6:35	4:15	8:25	9:55
6:55	5:55	6:55	4:35	8:55	10:25
7:15	6:10	7:15	4:55	9:25	10:55
7:35	6:25	7:35	5:15	9:55	11:25
7:55	6:40	7:55	5:35	x10:00	11:55
8:10	6:55	8:10	5:55	10:25	12:25
8:25	7:25	8:25	6:15	10:55	12:52
8:40	7:55	8:40	6:35	11:25	
8:55	8:25	8:55	6:55	11:55	
9:10	8:55	9:10	7:15	P.M.	
9:25	9:25	9:25	7:35	12:25	
9:40	9:55	9:40	7:55	12:55	
9:55	10:25	9:55	8:15	1:25	
10:25	10:55	10:25	8:35	1:55	
10:55	11:25	10:55	8:55	2:25	
11:25	11:55	11:25	9:25	2:55	
11:55	12:25	11:55	9:55	3:25	
P.M.	12:52	P.M.	10:25	3:55	
12:25		12:25	10:55	4:25	
12:55		x12:50	11:25	4:55	
1:25		12:55	11:55	5:25	
1:55		1:15	12:25	5:55	
2:25		1:35	12:52	6:25	
2:55		1:55		x6:30	

This 1923 timetable for streetcars in Wyoming shows a convenient schedule for commuters. Electric streetcars never brought the crime and city problems Wyoming detractors warned about. In fact, the cars were a little too late in coming and lost in competition with the new automobile. That happened in 1932 with the abandonment of the carbarn in Hartwell and the repaving of Springfield Pike. (Courtesy of John Diehl.)

William B. Hay, driving this automobile, was Wyoming's mayor from 1910 to 1924. In early 1918, fuel shortages caused by World War I, coupled with bitter winter weather, moved the Wyoming Baptist Church to open its doors to families who had run out of fuel for heating and cooking. Mayor Hay, known for his sense of civic responsibility, personally supplied the Baptists with fuel after the church had emptied its year supply of coal in just two weeks. (Alice Firbank Foster photograph; courtesy of Frank and Nancy Foster.)

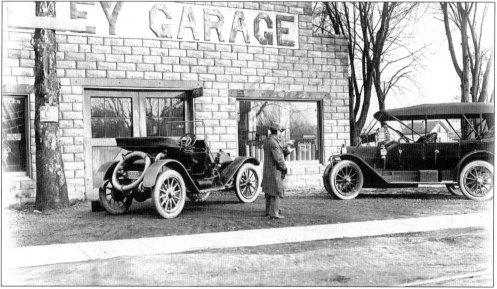

This photograph of the Valley Garage on Springfield Pike includes the tracks of the streetcar rails. The old Monroe Livery Stable in Wyoming became a relic in the face of advancing changes in transportation. Service garages like this one replaced most liveries and blacksmiths. (Alice Firbank Foster photograph; courtesy of Frank and Nancy Foster.)

The Cowing family, shown here in 1911, had one of the first electric cars in Wyoming, and even the women in the family learned how to handle a flat. (Courtesy of Gene-Ann Good Cordes.)

According to one Wyoming village ordinance, "Each car must be equipped with a bell, a horn, or a whistle which should be sounded at each corner, and when meeting or passing a horse-drawn vehicle." Established speeds were 10 miles per hour. (Courtesy of Gene-Ann Good Cordes.)

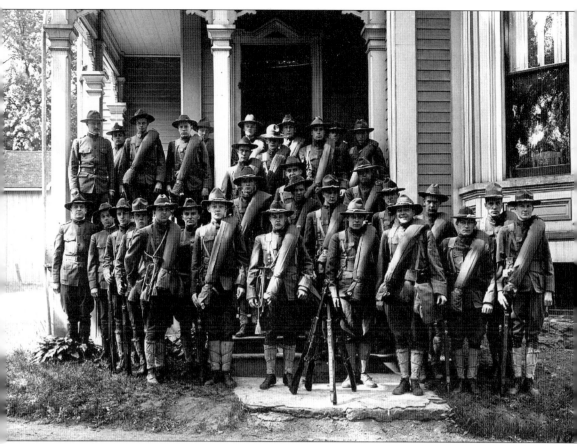

Many of Wyoming's Boy Scouts in this 1914 photograph would be called away to service in the Great War by 1918. Cub Scouts did not start in Wyoming until 1943, when the Wyoming Parent-Teacher Association agreed to sponsor Pack 81. St. James sponsored Pack 290 in 1955, and Pack 82 survives today under the sponsorship of Friendship Methodist Church. (Alice Firbank Foster photograph; courtesy of Frank and Nancy Foster.)

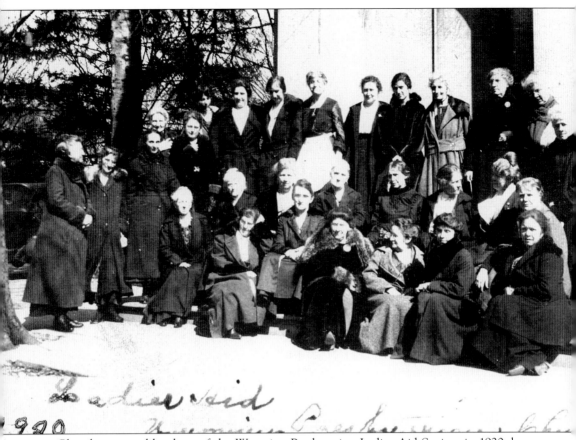

Church women, like these of the Wyoming Presbyterian Ladies Aid Society in 1920, became active in the Women's Christian Temperance Union in the years before Prohibition. Leaders of the anti-saloon movement were asked to speak at the church at least once a year. (Courtesy of the Wyoming Presbyterian Church.)

Just as they do today, Wyoming boys in the early 1900s could easily find a side yard to pick up a game of the very popular sport of baseball. (Alice Firbank Foster photograph; courtesy of Frank and Nancy Foster.)

The Fourth of July, now celebrated with a parade down Springfield Pike, attracted crowds in 1910 that participated in athletic contests and games like sack races and horseshoes. (Alice Firbank Foster photograph; courtesy of Frank and Nancy Foster.)

Ralph Foster's son is shown here with a little friend, Sara Ann Huber Myers, on a sidewalk in Wyoming. As mayor, Ralph Foster later said in 1951, when the village voted to become a city, "It has been the object of each council to keep Wyoming an outstanding residential community, a good place in which to live and bring up children." (Alice Firbank Foster photograph; courtesy of Frank and Nancy Foster.)

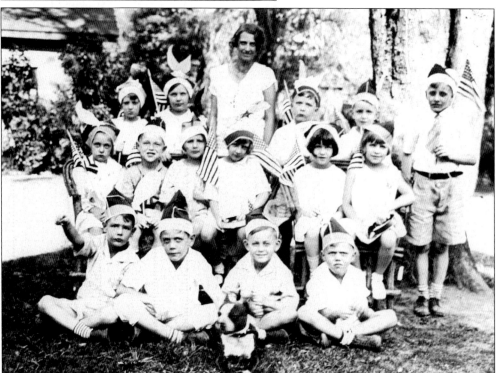

Ralph's wife, Helen Foster, was as active in the Wyoming community as her husband. Here, she and neighborhood children celebrate the Fourth of July in 1929. (Alice Firbank Foster photograph; courtesy of Frank and Nancy Foster.)

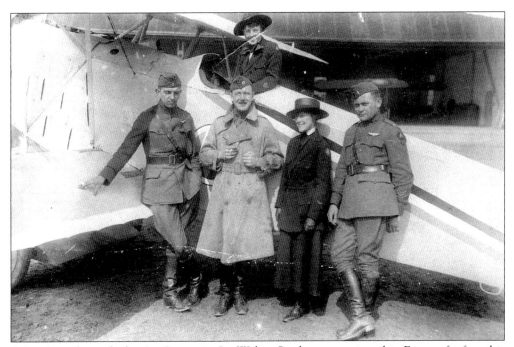

A bomber pilot with the Air Corps, 1st Lt. Walter Cordes was stationed in France, far from his hometown of Wyoming, during World War I. (Courtesy of Gene-Ann Good Cordes.)

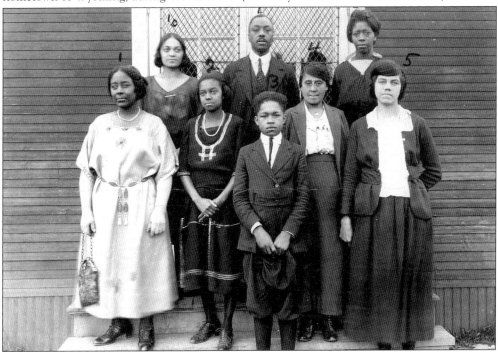

Several members of Wyoming's African American community gathered for this photograph in the 1930s. Pictured from left to right are (first row) Clara Lane, Viola Frances, Curtis Elliott, Mrs. Martin Roberts, Mrs. Jessie Bowles; (second row) an unidentified woman and Clarence Warner and his wife. (Courtesy of the Wyoming Historical Society.)

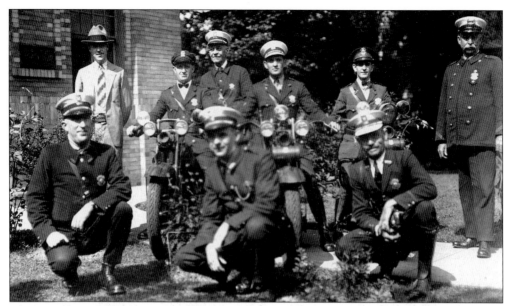

The men photographed here patrolled Wyoming by motorcycle in 1927. Frank Pendery was the first police marshal of the village, with a yearly salary of $100. George Kloster became the first motorcycle officer in 1910 and was shot and killed by the tracks near Cooper Avenue in 1912. When the city incorporated in 1948, it established the office of the police chief. (Courtesy of the Wyoming Historical Society.)

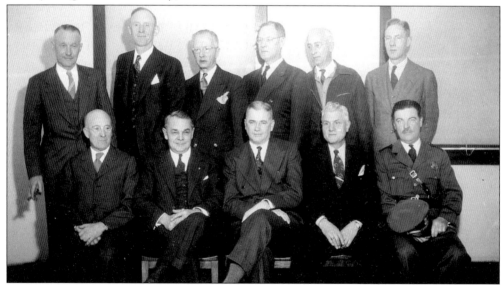

Frank S. Bonham was mayor of Wyoming from 1927 to 1939, later becoming a Hamilton County probate judge. Bonham Road was once known as Winton Road, creating confusion with the larger avenue to the west with the same name. It was renamed in 1949 in honor of the well-respected mayor. The Wyoming branch of the Public Library of Cincinnati and Hamilton County was also named Bonham Branch before a recent change from historic to location names for the neighborhood branches. Other members of this 1939 city council were C. E. Kern, T. Devenish, Royal Martin, R. Bond, J. Friend, F. J. Wrampelmeyer, C. B. Lewis, E. Pruden, J. R. Hegner, and Marshall Pat McDonough. (Courtesy of the Wyoming Historical Society.)

In 1941, this photograph of Elwood Moore, second from the right, was taken with his friends during their service in World War II. He was later killed in a plane crash. (Courtesy of the Wyoming Historical Society.)

A 1943 pamphlet, shown here, outlined ways that Wyoming citizens at home could make a difference in the war through resource conservation. Faced with rations on tires, gas, and automobile parts, the community was asked to "plan 'co-operative' shopping trips . . . ride busses . . . not ask for 'Special Deliveries' . . . and not allow youths to 'run around' in cars." (Courtesy of the Wyoming Historical Society.)

HERE ARE THE WAYS IN WHICH PATRIOTIC RESIDENTS OF WYOMING
WILL WAGE WAR ON WASTE

to Save Tires - Save Gasoline - Save Automobiles

Fully aware that Auto Tires and Auto Parts are no longer available and gasoline is to be rationed the residents of Wyoming are conserving all existing automotive equipment by observing the following:

Wyoming Residents will not use their cars unnecessarily.

Wyoming Residents will plan "co-operative" shopping trips.

Wyoming Residents form neighborhood "Share the Car" clubs.

Wyoming Residents will ride busses to and from Cincinnati.

Wyoming Residents will use trains for long distance traveling.

Wyoming Residents will co-operate with scheduled delivery services of Grocers, Milk Companies, Laundries, Dry Cleaners and Stores.

Wyoming Residents will not ask for "Special Deliveries."

Wyoming Residents will drive within the 35 miles per hour limit.

Wyoming Residents will watch for and obey all traffic signals.

Wyoming Residents will obey Stop Signs at all intersections.

Wyoming Residents will not allow youths to "run around" in cars.

Wyoming Residents will not chase Fire Engines or Police cars.

Wyoming Residents will go to church--and walk to church.

Wyoming Residents will practice good sportsmanship while driving.

Wyoming Residents give pedestrians the right of way.

Wyoming Residents keep cars in garages during Blackouts.

☆ ☆ ☆ ☆ ☆ ☆ ☆

Wyoming Residents who feel they are conscientiously observing these rules will display Twin V symbols on the rear window of their cars.

Wyoming citizens that observed waste-saving rules placed this square symbol on their automobile, promoting what was called the Twin V (for victory) Community. (Courtesy of the Wyoming Historical Society.)

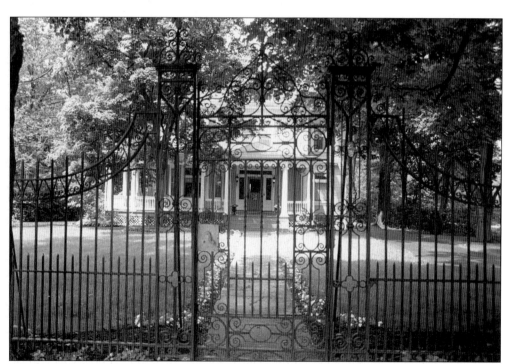

In 1912, Herbert Lape put up the intricate wrought-iron fence around 129 Springfield Pike. Thirty years later, owner Dr. Edward Dickson resisted neighborhood pressure all through the war years to keep his fence off the scrap metal pile. (Courtesy of the Wyoming Historical Society.)

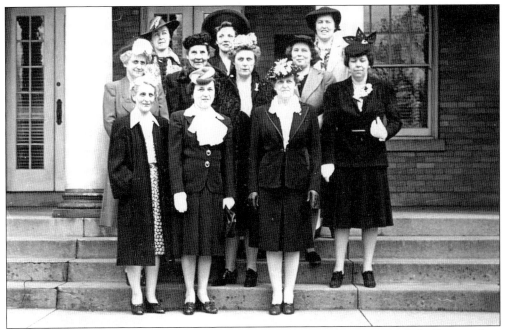

During World War II, Wyoming Woman's Club officers, shown here in 1942, led efforts to plant victory gardens all over Wyoming. During this time, their Garden Circle planted flowers around the village and sponsored a "dandelion week" to keep the long-suffering weeds from sprouting around the public buildings near the tracks. (Courtesy of the Wyoming Historical Society.)

Ralph Foster, son of photographer Alice Firbank Foster, was raised in Wyoming and served as mayor from 1941 until his death in 1959. Two great challenges he faced during his administration were the demands of the war effort on the community and the transition from village to city in 1949. The new city charter his administration crafted provided for a city manager and a council-at-large government. Foster also supervised an uneventful fluoridation of the city's water supply and led efforts to rebuild the civic center in 1948. (Courtesy of Frank and Nancy Foster.)

A Wyoming graduate himself, Henry Robert Piersawl taught at the Colony School from 1934 to 1941. After serving in World War II and another tour of military duty in the 1950s, he returned to a closed Oak Avenue School. Piersawl became the principal at Eckstein School in Glendale. (Courtesy of the Wyoming Historical Society.)

Soprano Nadine Roberts Waters was born into a musical Wyoming family. Her father, Van Roberts, a noted bass soloist, was the first African American supervisor of the Cincinnati Post Office. Waters, educated at the New England Conservatory of Music and trained in Paris, performed extensively in both America and Europe in the 1930s and 1940s. She was highly acclaimed overseas. (Courtesy of the Wyoming Historical Society.)

A winter party on Compton Road in the early 1950s shows farmland on the hill. In 1953, developer Stanley Barnhorn purchased 100 acres between Compton and Oregon Trail and built the Compton Woods subdivision. Dr. Charles and Iva Gooseman had owned the fields and fishing ponds of this country estate. (Courtesy of the Wyoming Historical Society.)

The Wyoming Golf Club leased a pasture on the Hollmann Brothers Dairy farm and eventually purchased the entire farm for its nine-hole golf course. Before that, village men had laid out a hardscrabble course that began at the southwest corner of Burns and Pendery Avenues, crossed over a rail fence (a challenge to the golfers), ran north up the fields to Springfield Pike, and then back down to the start. (Courtesy of the Wyoming Golf Club.)

The Wyoming Masonic Lodge No. 186 started meeting next to the Woodruff Building in 1887. The noise and bustle of the train station eventually convinced members to purchase the Cavett residence on the corner of Wyoming and Grove Avenues in 1923 and erect a lodge building at its rear. By allowing them meeting space, the Masonic lodge encouraged several new churches to form in Wyoming, including the Valley Temple and the First Church of Christ, Scientist. The building is now home to the Wyoming Fine Arts Center. (Courtesy of the Wyoming Historical Society.)

This Wyoming Civic Center is the third to stand on the corner of Worthington Avenue and Springfield Pike. Private donations helped the city rebuild a civic center after the 1948 fire. (Courtesy of the Wyoming Historical Society.)

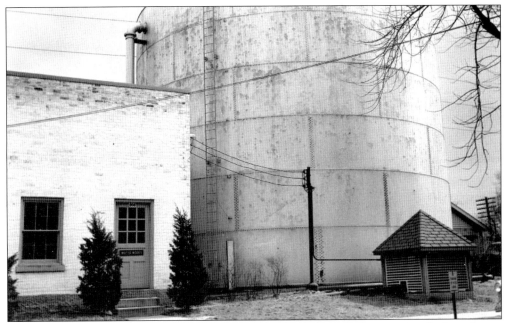

Wyoming was the first Ohio village to install a municipal plant, drawing its supply from driven wells. The summer after the experimental well was driven at the amusement hall, a terrible drought hit this region. People from miles around came to Wyoming to purchase water at 2¢ a barrel. This is a photograph of the old waterworks, replaced by the new building in 2000. (Courtesy of the Wyoming Historical Society.)

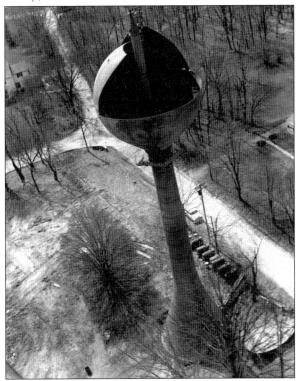

Here, the water tower under construction on Reily Road is being viewed by helicopter. The water tower replaced the reservoir in 1955. (Courtesy of the Wyoming Historical Society.)

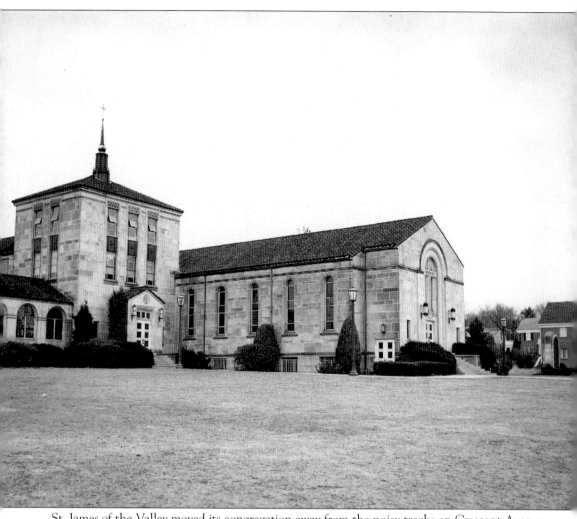

St. James of the Valley moved its congregation away from the noisy tracks on Crescent Avenue and to a new church on Springfield Pike in 1940. The church stands in front of Charles Woodruff's house, and for years, the Notre Dame de Namur nuns who taught at the school lived there. (Courtesy of St. James of the Valley Roman Catholic Church.)

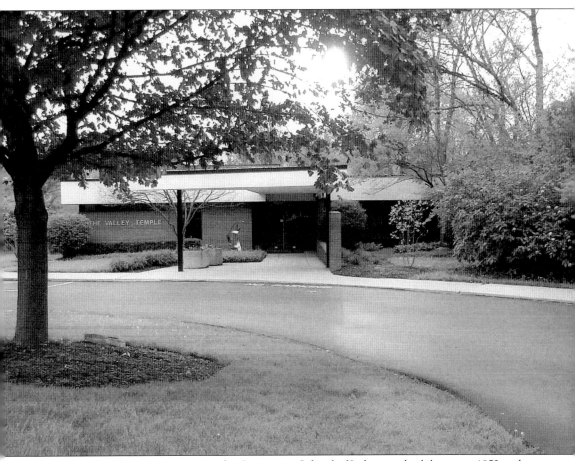

The Valley Temple traces its roots to the Cincinnati School of Judaism, which began in 1952 with a meeting of Reform Jewish families in North Avondale. Parents served as teachers, obtaining their curriculum from the Reform Movement's School for Judaism. By the school's second year, classes were being held in Wyoming, eventually moving to the Wyoming Masonic Temple, and finally the new temple. The temple shown here was built in 1974. (Courtesy of Robert and Clare Deutsch and the Valley Temple.)

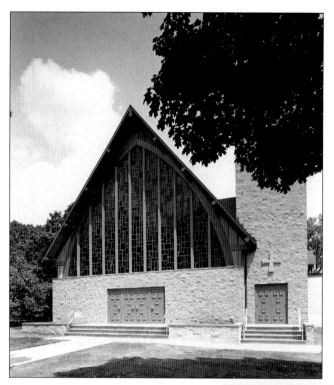

An extensive rebuilding of the Church of the Ascension Episcopal began in 1963, and in 1965, the Church of the Holy Trinity in Hartwell merged with the Wyoming congregation to form the Church of the Ascension and Holy Trinity. (Courtesy of the Wyoming Historical Society.)

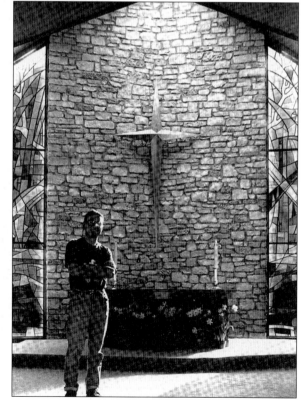

Friendship Methodist Church built a new sanctuary in 1992. Years earlier, Amphay Oudomsouk and his family had immigrated to America from Laos and lived in the basement of Friendship when they first arrived. The church chose this talented young artist to design stained glass windows for the new building. He accepted in appreciation for what the church had done for his family. (Courtesy of Friendship Methodist Church.)

Members of Wyoming's city council, meeting in the mid-1950s, include Bob Short, Walter Cordes Sr., Ralph Foster, Fred Gedge, Tom Porter, Fred Wrampelmeier, Clarence Bud Porter, Carl Kern, Chief Joerling, Charles Weber, and Nettie Alexander, longtime and respected clerk for the council. (Courtesy of the Wyoming Historical Society.)

Municipal facilities had outgrown their space at the city building by the 1990s. Groundbreaking for new police and fire stations and the life squad took place in 1993. (Courtesy of the Wyoming Historical Society.)

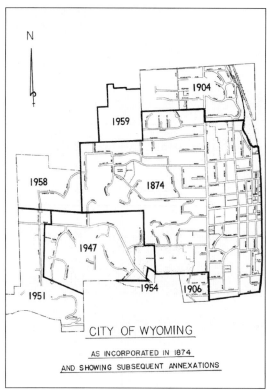

Wyoming's annexations during the 20th century allowed the city to offer moderately priced housing developments within its borders, which maintained economically balanced residential growth. (Courtesy of the Wyoming Historical Society.)

This farmland in the Wyoming hills disappeared in the 1950s and 1960s as the city annexed property west of Springfield Pike. (Courtesy of the Wyoming Historical Society.)

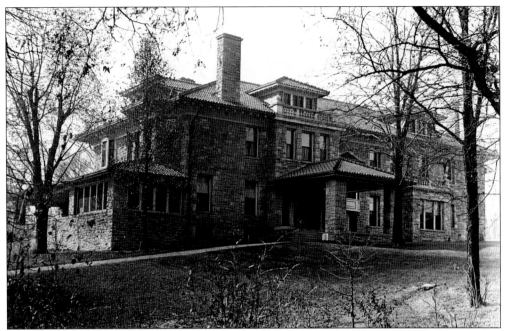

The Edward Stearns house at 333 Oliver Road, new in 1910, was the last of the large estates built by the Stearns family in Wyoming. It took four years to build and represents the arts and crafts movement of that time. Its stone surfaces and simple lines were reactions to the fussiness of Victorian architecture. (Courtesy of the Wyoming Historical Society.)

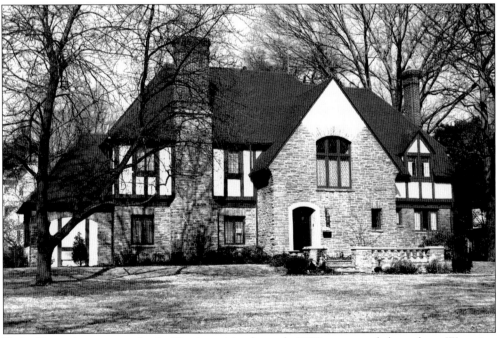

Tudor Revivals, very popular in Cincinnati in the early 1900s, appeared throughout Wyoming during this time. The house at 701 Springfield Pike is an excellent example of this style, based on 17th-century Elizabethan architecture. (Courtesy of the Wyoming Historical Society.)

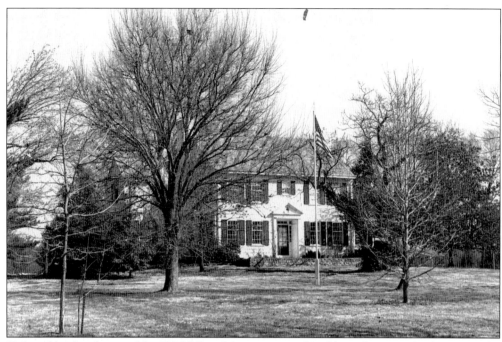

Today older farmhouses, like 222 Hilltop Lane, mix comfortably with post-1950s homes in the Wyoming hilltop area. (Courtesy of the Wyoming Historical Society.)

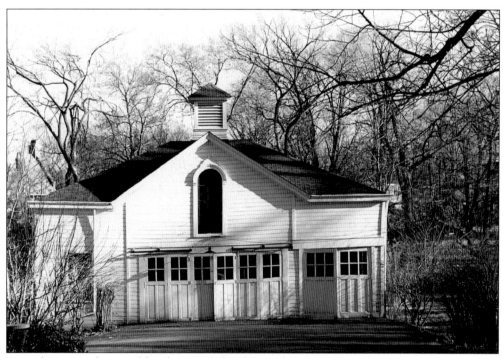

Several carriage houses, like the one behind 229 Elm Avenue, still exist alongside modern garages in Wyoming's historic village district. (Courtesy of the Wyoming Historical Society.)

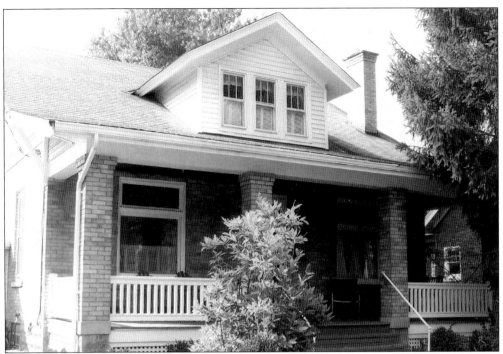

The house at 137 Springfield Pike, like many bungalows built in Wyoming after 1900, exhibits a low-pitched gable roof, wide roof overhangs, and a gable-roofed front porch. Bungalows evolved from the 1890s California Craftsman movement, which tried to preserve simplicity and craftsmanship in architecture. (Courtesy of Beth Emanuelson and Jim Falkenstine.)

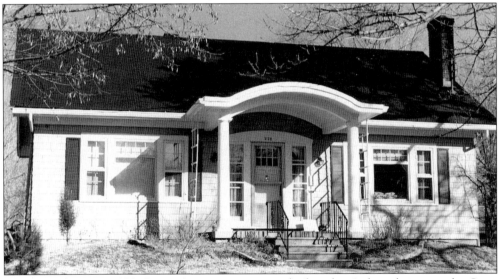

The Sears home, at 220 Grove Avenue, is patterned after the Ardara design in the Sears Catalogue. Sears, Roebuck and Company began to sell plans and material for houses in 1908 and published its last catalogue of home designs in 1940. There was no such thing as a typical Sears plan, although the bungalow, being so popular a style during this era, is often stereotyped as a Sears home. Where a boxcar could drop off materials, a Sears home could be built, and Wyoming offered such an opportunity. (Courtesy of the Wyoming Historical Society.)

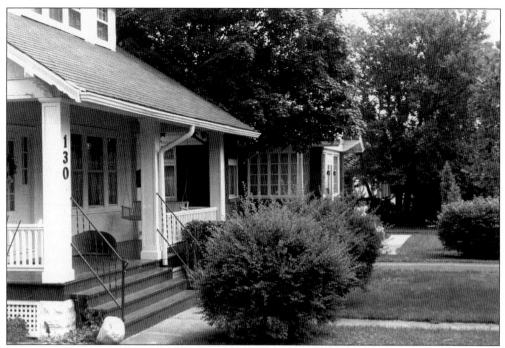

Bungalows like 130 Springfield Pike and its neighbor answered a growing need for lower-priced housing all over the country and helped to create a healthy balance of incomes in Wyoming. (Courtesy of the Wyoming Historical Society.)

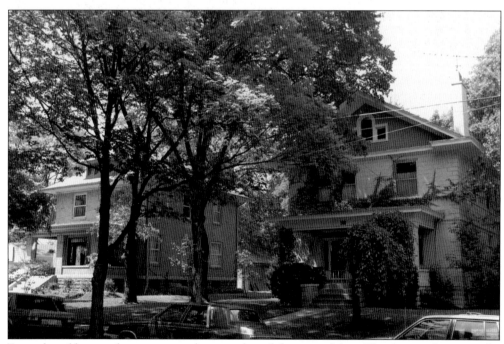

Examples of homes that represent the rise of a solid, successful middle class in America, the backbone of Wyoming's demography today, are 312 and 318 Poplar Avenue. (Courtesy of the Wyoming Historical Society.)

Otto Armleder, a successful businessman and philanthropist, razed this high Victorian-style house at 104 Elm Avenue built by George George and constructed a new American Foursquare there. Wyoming's architecture, now considered historic, was fluid in its creation, changing to meet the needs or whims of homeowners in the 19th and 20th centuries. (Courtesy of Liz Weis.)

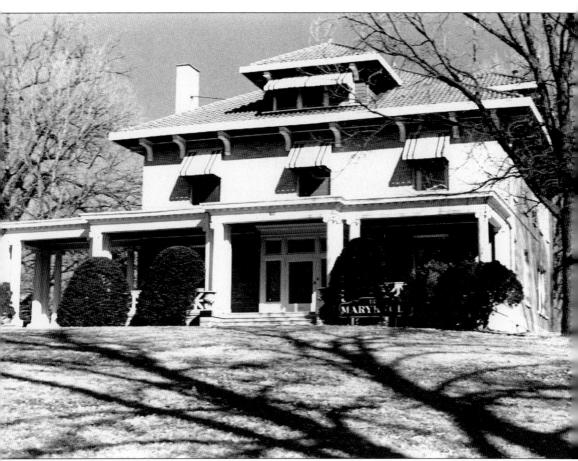

The home that Otto Armleder built at 104 Elm Avenue is an outstanding example of post-Victorian, eclectic architecture. Symmetrically designed in a variation of Georgian Colonial Revival, it has every stylized feature good money could buy, from red pantile roofing to a mosaic tiled porch. Armleder did save the porch columns and porte cochere from the original house, incorporating them into the newly designed house. Willed to the Archdiocese of Cincinnati when Armleder died in 1935, the house is now privately owned. (Courtesy of the Wyoming Historical Society.)

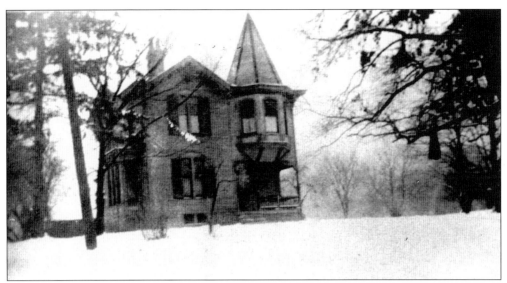

In 1900, 441 Springfield Pike was a Victorian Gothic–styled home, with a conical tower and a wide lawn sweeping down to Springfield Pike. Front lawns were very long on the turnpike to keep houses far from the dust kicked up first by stock herds and, later, automobiles. (Courtesy of the Wyoming Historical Society.)

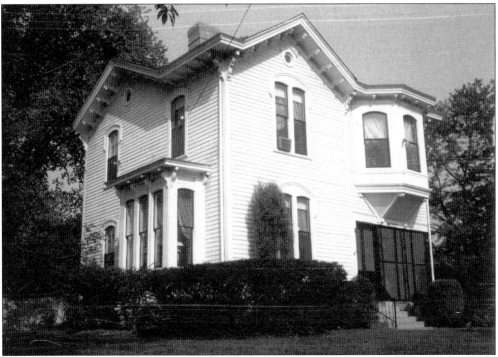

The historic landscape and the appearance of 441 Springfield Pike today has changed drastically. An apartment house sits in its front lawn now, and the conical tower was removed years ago. Many of the estates on the west side of Springfield Pike lost their long front lawns during the Depression era, when cash-strapped descendents of the original owners sold unnecessary parcels on the lots. (Courtesy of the Wyoming Historical Society.)

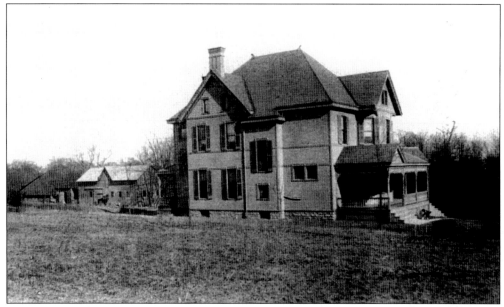

In 1900, 301 Pleasant Hill was a typical Victorian-era farmhouse, surrounded by fields and the hills to the west.

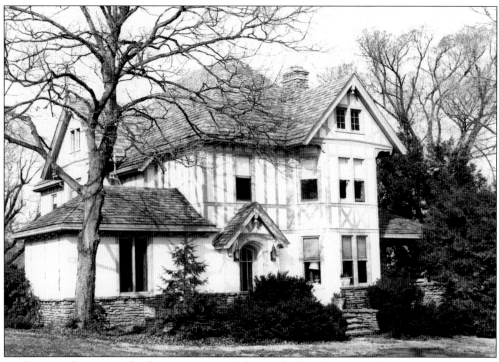

In the next few years, the house was restyled with half-timbering and stucco to give it the popular Tudor look. (Courtesy of Roger and Mary Honebrink.)

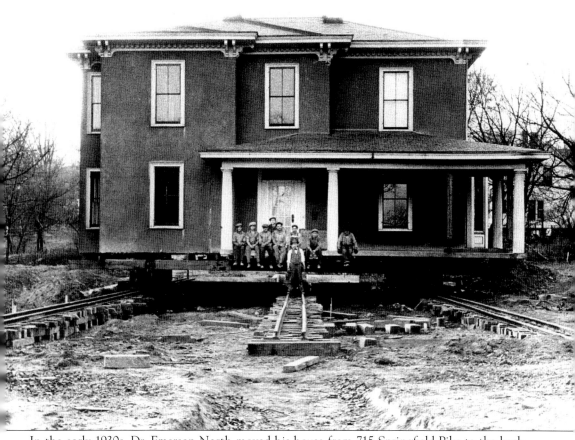

In the early 1930s, Dr. Emerson North moved his house from 715 Springfield Pike to the back of his newly created subdivision, Dorino Place. Many houses in Wyoming have been moved to different locations, including another original house to this property owned by the Peabody family. Purchased for just $500, it ended up on Brooks Avenue. (Courtesy of the Wyoming Historical Society.)

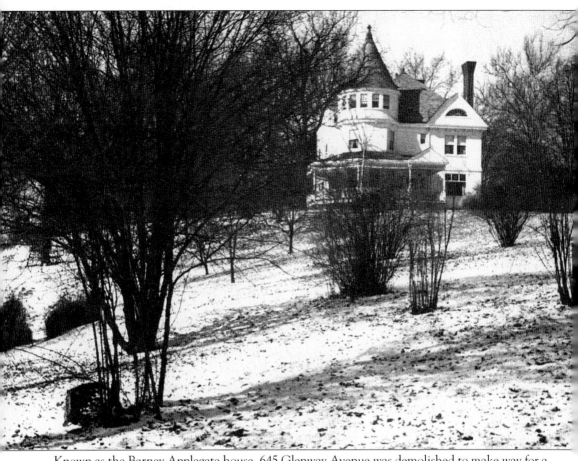

Known as the Barney-Applegate house, 645 Glenway Avenue was demolished to make way for a more modern home in the 1960s. (Courtesy of the Wyoming Historical Society.)

Councilman David Savage discusses the Woodruff Building with police chief James Donovan in 1982. Soon after this photograph was taken, the city demolished the building, despite a public campaign against its destruction. (Courtesy of the Wyoming Historical Society.)

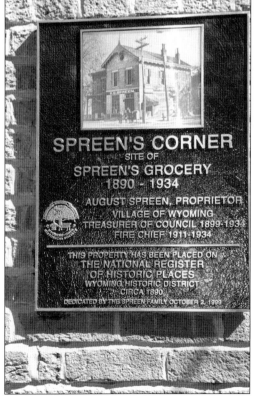

The Spreen's Grocery historical marker was dedicated by members of the Spreen family in October 1999. The building has been accepted by the keeper of the National Register of Historic Places. (Courtesy of the Wyoming Historical Society.)

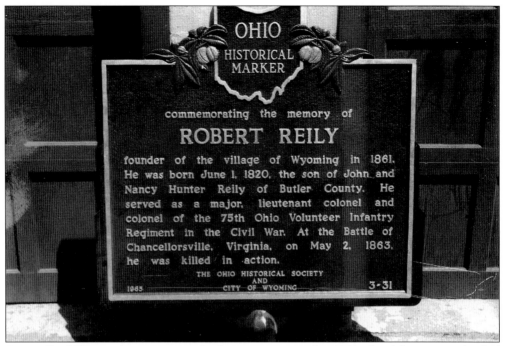

During Fred Wrampelmeier's mayoral administration in the 1960s, local historians clarified Robert Reily's name, for years misspelled as Reilly or Riley. The city changed street signs to reflect the correct spelling, and an Ohio Historical Society marker honoring Reily was presented to the city in 1965. (Courtesy of the Wyoming Historical Society.)

The Grove Avenue Playground was renamed Foster Memorial Park in honor of Wyoming's 15th mayor, Ralph Foster. Sons Frank (left) and Stanley Foster and grandson Erik Foster attend the restoration of the signage in the 1980s. (Courtesy of Frank and Nancy Foster.)

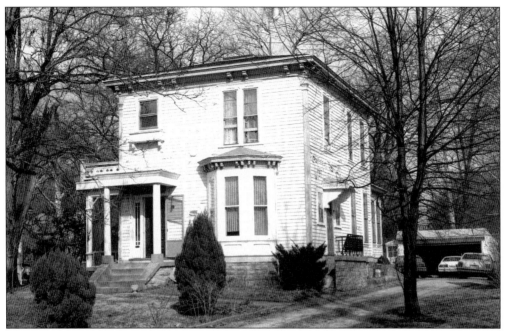

One of many historic homes outside the designated historic district, 22 Springfield Pike is still an integral part of the architectural and social history of this community. (Courtesy of the Wyoming Historical Society.)

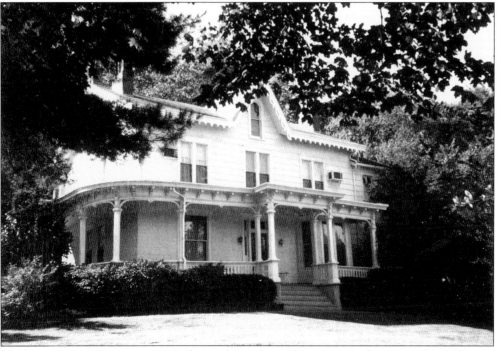

The Estes Cowing House, at 230 Reily Road, is today without its striped awnings, but its history is strongly linked with the development of this community. (Courtesy of the Wyoming Historical Society.)

Gertrude McIlwain (center), standing on her porch at 310 Wyoming Avenue, was one of Wyoming's first preservationists. In the 1950s, she and her husband restored this house, once the estate of George House, to its previous elegance. (Courtesy of the Wyoming Historical Society.)

Wyoming Centennial Parade in 1974 celebrated 100 years of history with over a week of special events. A historical musical revue was performed, centennial luncheons were served, alumni gathered, and residents participated in a grand parade down Springfield Pike. (Courtesy of the Wyoming Historical Society.)

Wyoming has placed wrought-iron flower stands on its main street corners since the 1930s, when the Wyoming Woman's Club began the project along Springfield Pike. (Courtesy of the Wyoming Historical Society.)

Wyoming Gazebo, next to the old town hall, now Sturkey's Restaurant, is home to summer concerts and public gatherings in today's Wyoming. (Courtesy of the Wyoming Historical Society.)